CHELTENHAM
THROUGH TIME
Roger Beacham
& Lynne Cleaver

AMBERLEY PUBLISHING

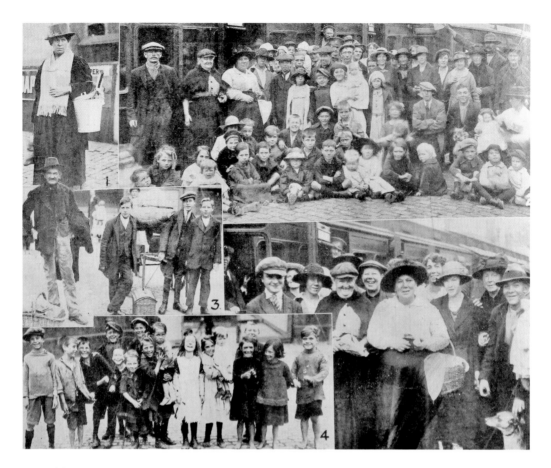

Hop-Pickers

In August 1921, Cheltenham families set off on their annual holiday to Bosbury, Herefordshire, by train, where they would all take part in hop-picking. Note the lady (*top left*) with her possessions in a bucket as she had no other way of carrying them; also many of the children in the bottom picture are barefooted.

First published 2011

Amberley Publishing
The Hill, Stroud
Gloucestershire, GL5 4ER

www.amberley-books.com

Copyright © Roger Beacham & Lynne Cleaver, 2011

The right of Roger Beacham & Lynne Cleaver to be identified as the Authors of this work has been asserted in accordance with the Copyrights, Designs and Patents Act 1988.

ISBN 978 1 4456 0295 0

British Library Cataloguing in Publication Data.
A catalogue record for this book is available from the British Library.

Typeset in 9.5pt on 12pt Celeste.
Typesetting by Amberley Publishing.
Printed in the UK.

Introduction

The writer of Ecclesiastes reminds us that 'of making of many books there is no end'. This is certainly true of Cheltenham in recent years, as there have been a number of histories and photographic books of the town published. It is inevitable, therefore, that we will have reproduced some photographs with which readers will be familiar. However, we hope also to have included some which will be new to them. The majority of the photographs, with a few exceptions, are taken from a supplement to the weekly newspaper the *Cheltenham Chronicle* known as the *Gloucestershire Graphic*, printed between 1901 until the wartime paper shortage caused it to cease production in April 1942.

We hope older readers familiar with the town will find as much pleasure as we have had in rediscovering once familiar but now long vanished businesses and buildings. As a boy in the 1950s, I enjoyed peering through the windows of Honeysett and Howlett, electrical contractors and watch and clock repairers in Clarence Street. The premises had altered little since the 1920s. Within the shop, a Bunsen burner was alight and two elderly people could be seen at work, Mr Honeysett, doing electrical repairs, and a white-haired Mrs Honeysett, née Howlett, repairing clocks. Interest was added when my grandmother told me that we were related to the people inside, her mother having formerly been a Miss Howlett. The shop has long since vanished, the site covered by the vast block of Cheltenham House. Another reminder of times past came upon seeing the photograph of the Cadena Oriental Café, with memories of the aroma of roasting coffee beans and, as a very small boy, of attending my uncle and aunt's wedding reception there. Although I could remember that it had been situated in the Strand, I was surprised at how completely it had been absorbed and remodelled by the neighbouring bank. For Lynne, having moved here from Yorkshire fifteen years ago, the experience

of compiling this book has been a steep learning curve, bringing a new awareness of the town and its development. Even during the months we have been at work the town has continued to change. At the time of writing, the Coliseum in Albion Street, familiar to previous generations as a variety theatre and cinema, with a façade dating from the early nineteenth century, is being demolished. Lynne has even had to re-photograph several of the High Street shop premises as they had altered since beginning this project. Change occurs ever more rapidly and the importance of making a visual record now and in the years to come becomes increasingly important and necessary.

We hope that our readers will find as much pleasure in recalling scenes of the past as we have had in assembling the collection.

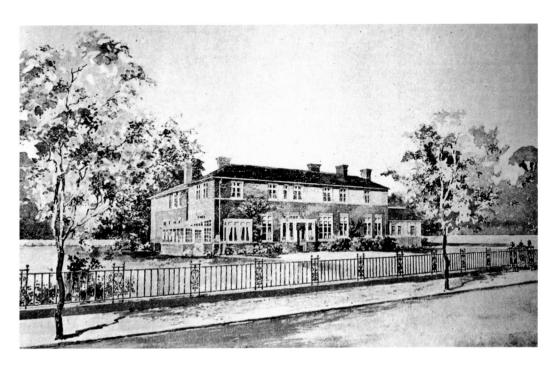

Pengwern College

Built in 1901 for Mrs Adelaide Pearson, Pengwern College for Girls in Pittville Circus Road later expanded to incorporate the neighbouring house, Sunnyside. By the Second World War the whole complex had become a maternity hospital – the actor Martin Jarvis was born at Sunnyside in 1941 – and afterwards it became a home for the elderly. In more recent times, Pengwern has been separated from Sunnyside and, reverting to its original name, used as a children's home. The building is currently being offered for sale by the County Council.

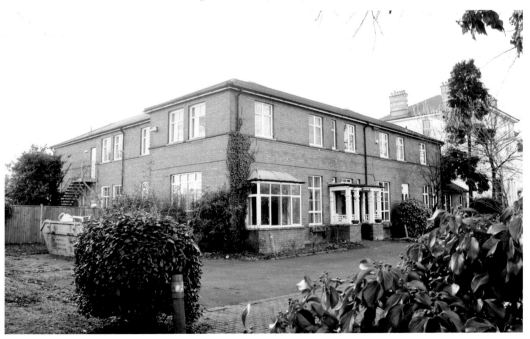

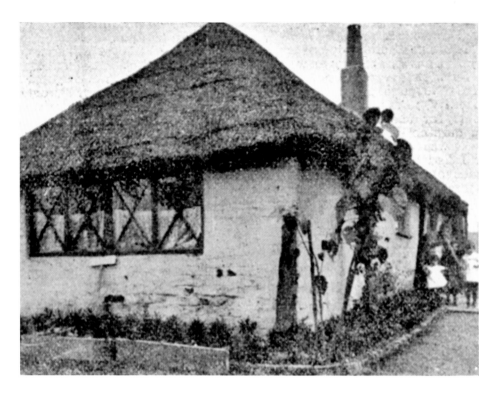

Hewlett Road

This three-roomed, thatched cottage in Hewlett Road was occupied in 1901 by the widowed Catherine Bennett, a charwoman, and her son William, a bricklayer's labourer. When this photograph was published in 1904, the *Graphic* commented 'a stone's throw from Pittville Circus Road, ninety-nine persons out of a hundred would not notice this rustic bit and its modern surroundings'. The cottage appears to have stood near the site of Brunner's Bakery, opened in 1932, where the most delicious cakes and chocolates were made for their shop and café in Clarence Street. The bakery in turn was demolished to make way for the present modern flats named after Fr James Donovan, a much-loved rector of St Gregory's Catholic Church.

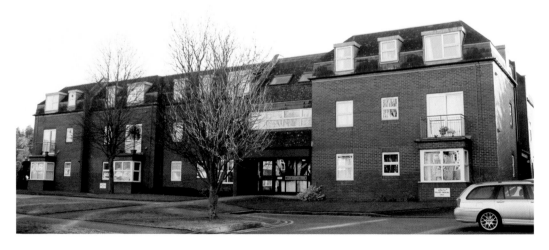

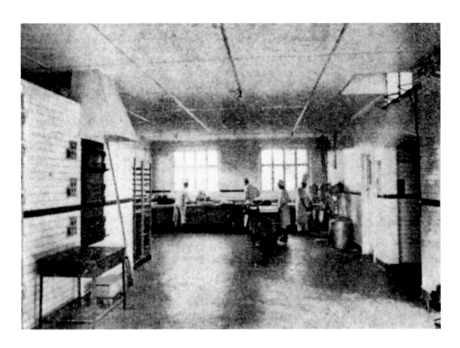

Brunner's Bakery, Hewlett Road
Shown in 1932, the bakery, described as 'hygienically perfect' was designed by local architects L. W. Barnard and Partners. The top photograph shows the electrically driven mixers, kneaders and refiners.

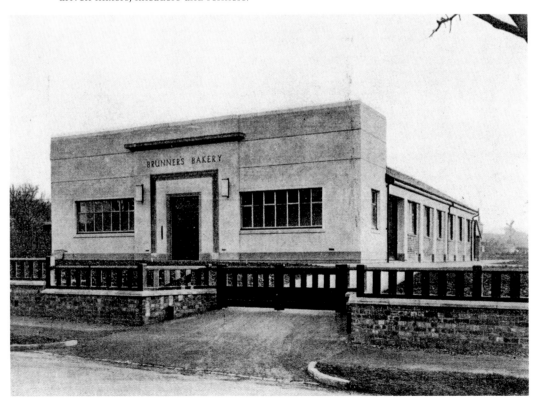

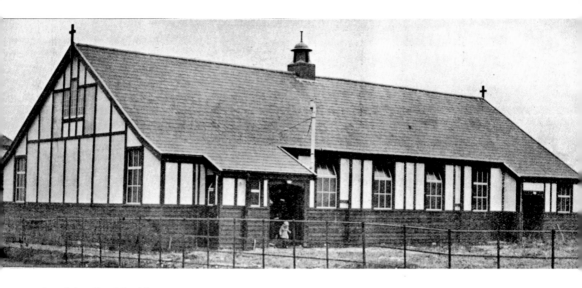

St Michael's, Whaddon

There were very few houses in Whaddon Lane (Whaddon Road from 1927) when in 1907 All Saints' Church in Pittville established a mission room dedicated to St Michael. With the development of the Whaddon estate a larger building was needed and, on a different site, the new St Michael's was blessed by the Bishop of Gloucester in 1937. This in turn was replaced by the present hexagonal building with a copper roof in 1966, the former church becoming a hall. After the destruction of Whaddon Methodist Church by fire, the two congregations came together to share the St Michael's building, when the old church hall was replaced by the present Cornerstone Centre, serving the wider community.

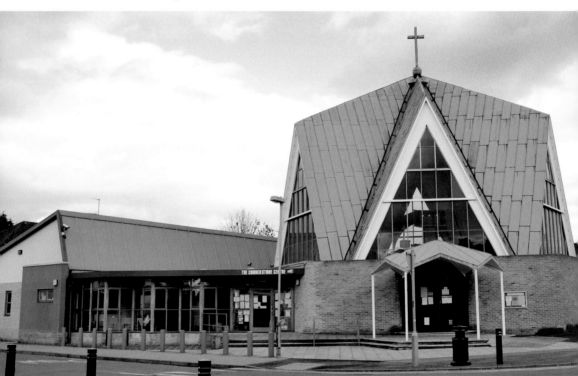

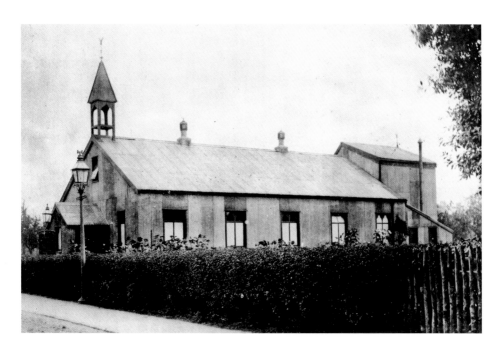

Walker Memorial Church

Standing in the almost rural Whaddon Lane in about 1905 is the corrugated iron church founded in 1877 by the Revd John Walker. He has been described as 'by conviction a strict Calvinist and in terms of church order a Presbyterian'. In its early years, it was known as the Scotch Church or the Church of Scotland, though it was never formally associated with that body, and, after the founder's death in 1911, was renamed the Walker Memorial Church. In the 1980s redevelopment took place; the old building was replaced by flats known as Claremont and the new Evangelical Free Church, approached through an archway and built at the rear, opened in January 1988.

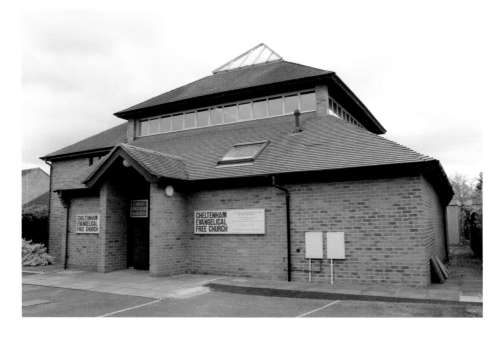

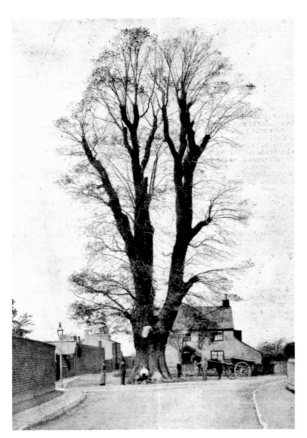

Maud's Elm

Marked on early maps as Maul's Elm, the 80-foot-high Maud's Elm stood in Swindon Road near Elm Street. A legend developed that a lovely young woman named Maud Bowen was buried here, having falsely been thought to have committed suicide. The legend says that the tree grew from the stake driven through her body. The tree remained a landmark until, in July 1907, a large branch fell. Having been declared unsafe, the rest of the tree was removed and today its site is marked only by a block of post Second World War flats seen below known as Maud's Elm House.

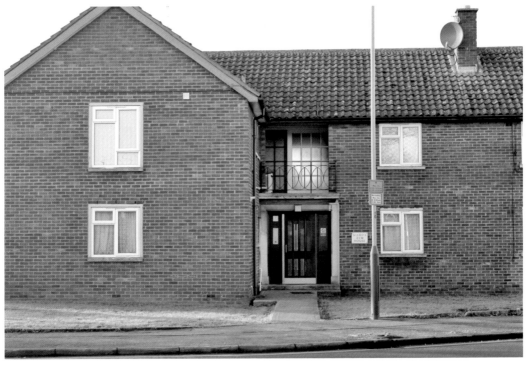

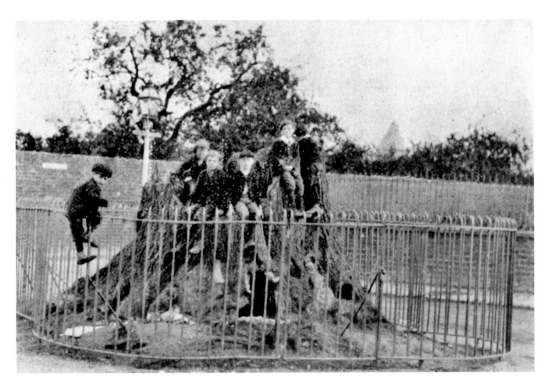

Maud's Elm

This old photograph show the remaining stump protected by railings erected in 1907 by Cheltenham Corporation.

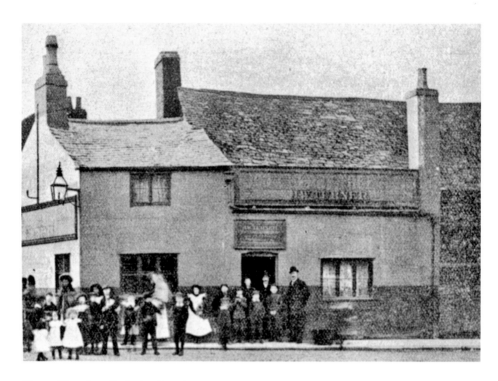

Cherry Tree Inn, Swindon Road

Founded in the early nineteenth century, the old Cherry Tree Inn stood at the corner of Whitehart Street and Swindon Road. It is shown here immediately before demolition by the GWR in 1905, prior to the laying of the Honeybourne line. On the Swindon Road side, nothing is left to suggest that the street once ended there or that a public house once stood on the site. The rail line itself has become a cycle way and footpath.

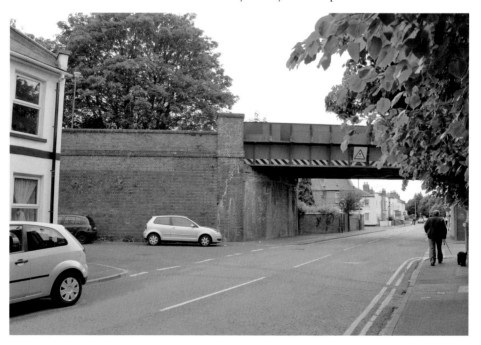

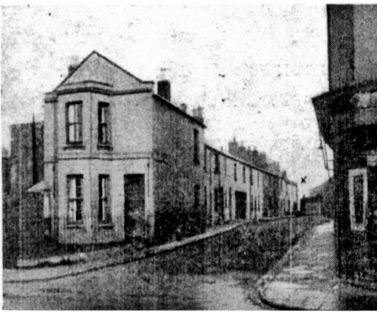

Whitehart Street

Whitehart Street's only claim to distinction is that in 1839 No. 20 was the birthplace of the illusionist John Nevil Maskelyne. The photograph of 1948 was taken at the time of the unveiling of a commemorative plaque by John's grandson, Noel Maskelyne. Originally placed in the old Town Hall, it can now be seen in the foyer of the Everyman Theatre. Since then both the more substantial house on the left and the shop on the right have been demolished, leaving the remaining houses dominated by the railway embankment.

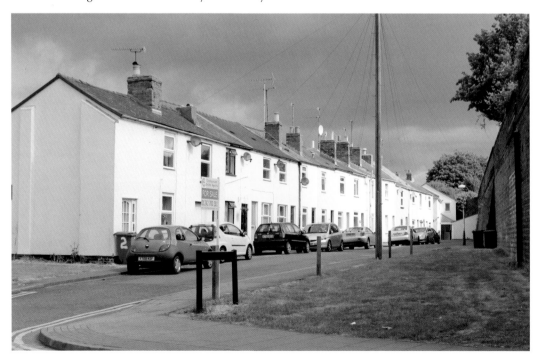

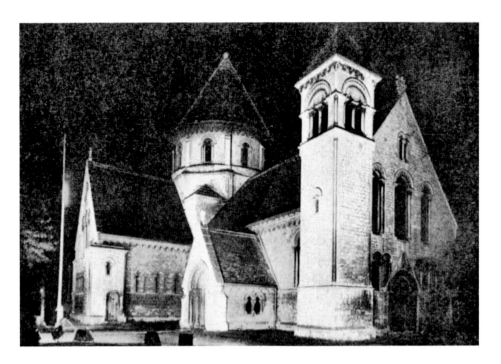

St Peter's Church, Tewkesbury Road

St Peter's Church in Tewkesbury Road illuminated for the Coronation of King George VI and Queen Elizabeth in May 1937. It was built between 1847 and 1849 to serve what was then the poorest area in the town. Designed by Samuel Whitfield Dawkes in neo-Norman style, it has, sadly, ceased to be a parish church. No longer can the glow of the sanctuary lamp be glimpsed by the passerby. The interior has been cleared and the furniture and fittings distributed among other local churches. Though still owned by the Church of England, the building is now a centre for Christian youth activity known as The Rock.

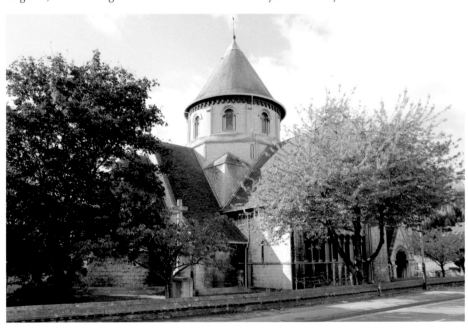

Evesham Road

The development of gardens is not new. In 1934, local builder W. H. Bowd erected this detached house and a pair of semi-detached houses in the garden of Evesham House in Evesham Road. Now they too have been replaced by an apartment block named Grosvenor House. Although effort has been made to make it sit harmoniously with the neighbouring terraces, which on the whole succeeds, it is spoilt by having a mansard roof.

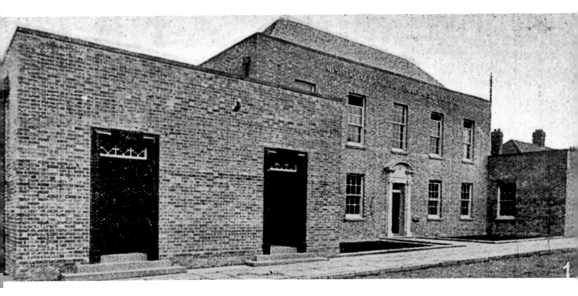

Labour Exchange, St Paul's Street, South

Forerunners of the present Job Centres were the government-run Labour Exchanges, originally the vision of Winston Churchill and William Beveridge. Opened in December 1935 in St Paul's Street, South, the Exchange is built in a pleasant neo-Georgian style with the cipher of King George V still visible above the centre door. Now known as Murray House, it provides student accommodation.

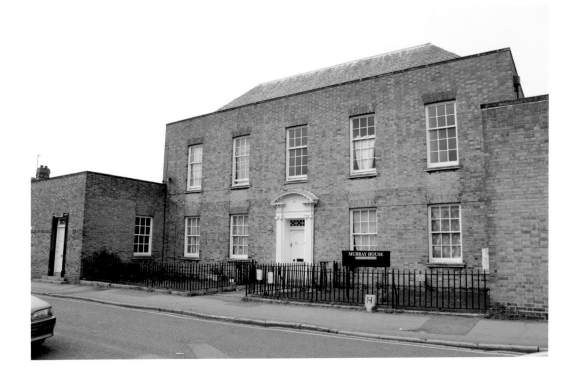

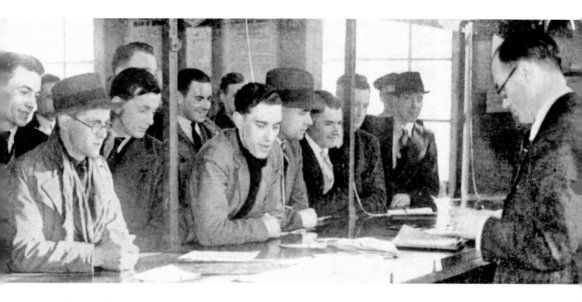

Labour Exchange, St Pauls Street, South
This photograph of April 1940 shows men of twenty-five years of age registering for war service. Seen below, the present Job Centre in North Street offers the latest in IT for its users.

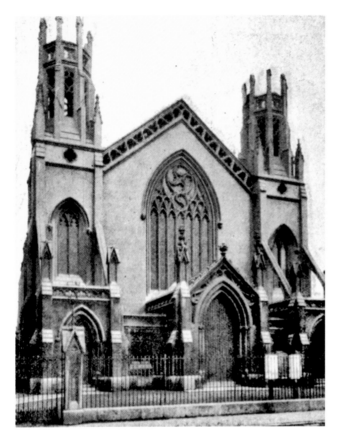

Highbury Congregational Church, Winchcombe Street
There was talk of divine retribution when it was announced that Highbury Congregational Church in Winchcombe Street was to be demolished to make way for a cinema. Built in 1850–52 in a Gothic Revival style, it had succeeded the first chapel opened in Grosvenor Street. The last services were held here in February 1932, when the congregation moved to its present building in Priory Terrace.

Inset: Digging the foundations for the present church building.

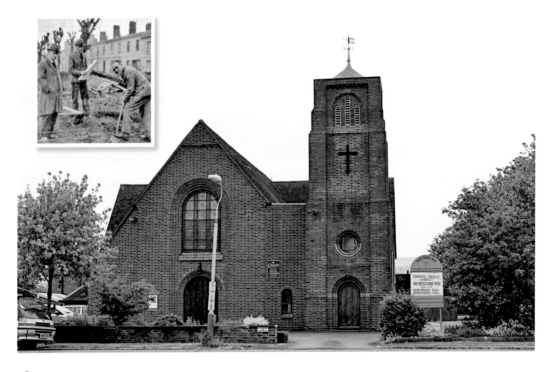

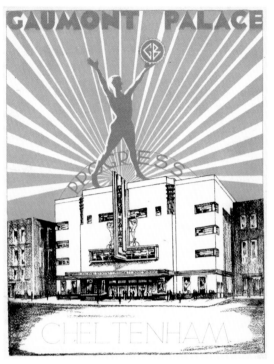

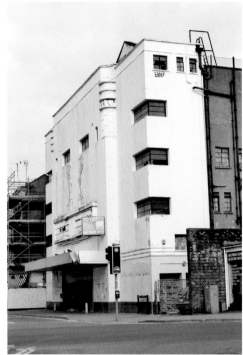

Highbury and Odeon, Winchcombe Street
Designed by W. E. Trent, the new Gaumont Palace opened with Conrad Veidt in *Rome Express* on 6 March 1933. Later known as the Odeon, it had been built with full stage facilities and presented variety shows, pantomimes and pop concerts. When the Beatles appeared here in November 1963, hordes of screaming fans surrounded the building. Closed in 2006, the art deco maidens cavorting with reels of film on the façade await a new purpose for their building.

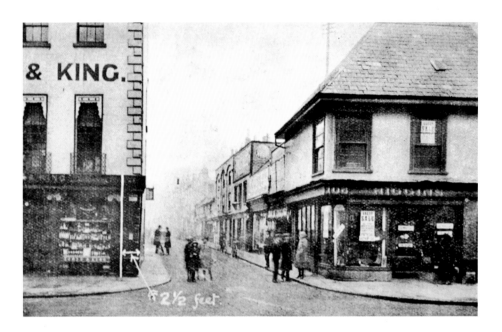

Winchcombe Street

Looking from the High Street towards Winchcombe Street in 1923, the shop on the right, lately occupied by F. E. Higgins, portmanteau maker, was about to be demolished to make way for a Swiss chalet type building belonging to Dunn's the hatters. It was suggested that at the same time the road be widened by taking back the building on the left by 2½ feet, then occupied by Lloyd and King chemists. However, when Winchcombe Street was redeveloped in the mid-1960s, it was the right side that was set back, the corner property now being occupied by a branch of Cheltenham & Gloucester Plc. The shop on the left, at present occupied by Thomas Cook's, travel agents, remains relatively unchanged. Look at the Winchcombe Street side wall (*see inset*) on which can still be seen two old iron signs, one of which still points to Pittville Spa.

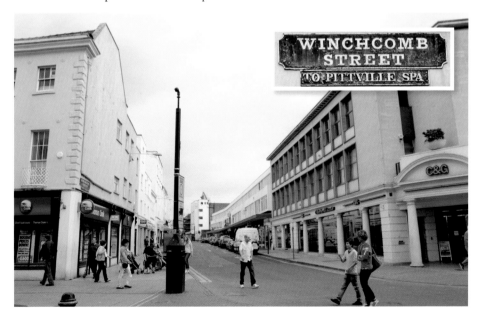

Liberal Committee Rooms, Albion Street

In 1910, two General Elections were held. At the first, in January, Viscount Duncannon was elected as the Conservative member for the town, though the election resulted in a hung Parliament. At the second election in December, Richard Mathias was elected for the Liberals. Though the Conservatives, together with the Liberal Unionists, gained the greater number of votes, the Liberal Party, with the support of the Irish Nationalists, formed a government. Mathias's election was declared void on petition and at the by-election in April 1911, James Agg-Gardner, by a narrow majority, regained the seat for the Conservatives. Here are shown the Liberal Committee Rooms at the junction of Portland and Albion Streets in December 1910. Today the premises are occupied by a hairdressers and a fast food outlet.

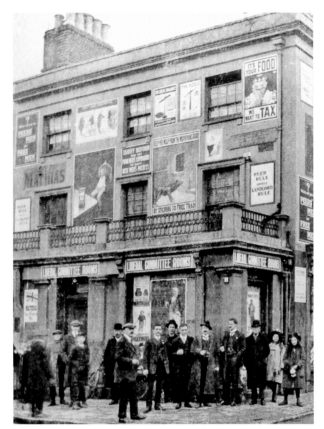

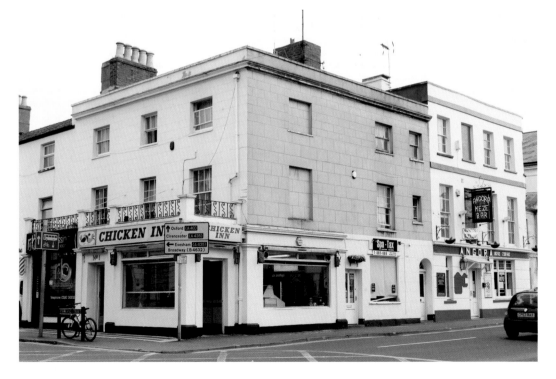

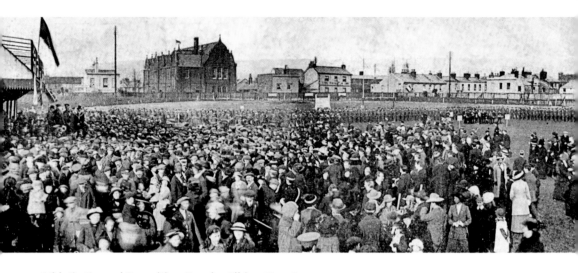

Athletic Ground Recruiting Parade, Albion Street

This photograph shows the Athletic Ground in Albion Street with, in the background, the former All Saints' Church School in Fairview Road. On 10 April 1915, the Athletic Ground was the site of a great recruitment meeting. During Easter week that year, a series of recruitment meetings had been held all over the town and culminated in a procession over a mile long on the Saturday, headed by the Mayor on horseback, which can be seen in the photograph on the following page.

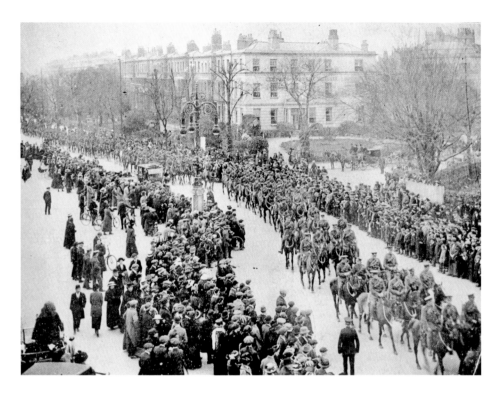

Recruiting Parade, Montpellier

Accompanied by two Brigadier Generals, their staff officers, and a host of others, including the Fire Brigade and the Boy Scouts, the procession made its way from Montpellier along Fairview Road and Hewlett Road to Albion Street. After such a great effort it must have been very disappointing for the organisers when only one person responded! No wonder conscription had to be introduced the following year. The Ground was developed in the 1980s when one of the new roads was named after Tom Price, a local man who had played rugby for England.

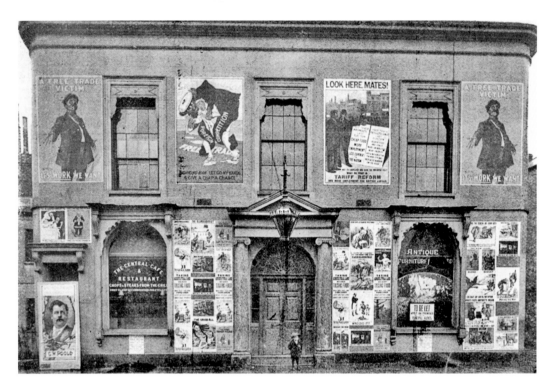

Coliseum, Albion Street
Originally, the smart showrooms and workshops of furniture maker John Alder, this Georgian building in Albion Street became the Conservative Club in 1881. It can be seen here covered in posters for the 1909 General Election. The second photograph shows the 'beautifully furnished Coliseum Café' in 1922.

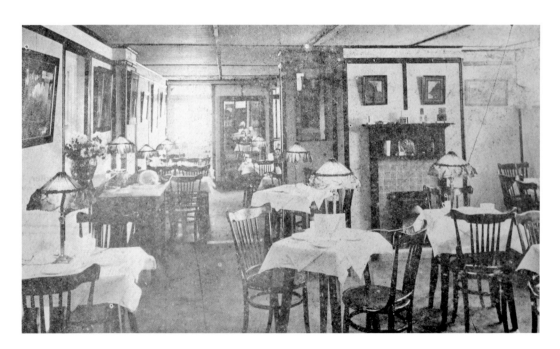

Coliseum, Albion Street

The early years of the twentieth century saw variety entertainment flourish, especially after the first Royal Command Performance in 1912. Retaining the façade of the former building, Cecil Gillsmith opened the Hippodrome on this site in September 1913. The twice-nightly performances included, one week, the young Gracie Fields. Renamed the Coliseum in 1920, it became a cinema in 1931 and later a bingo hall and snooker club before ending its days as a bar and club. It is shown here in 2010, a sad relic of its former days, awaiting redevelopment.

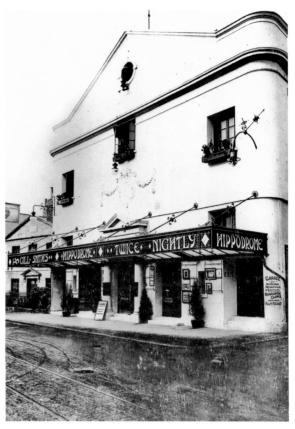

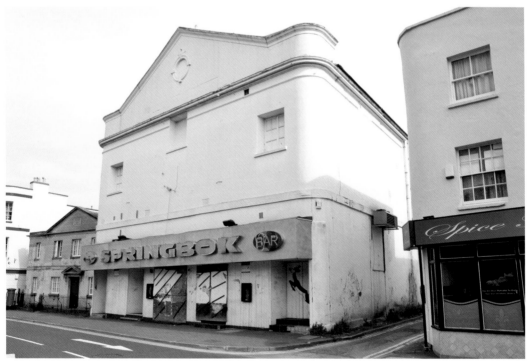

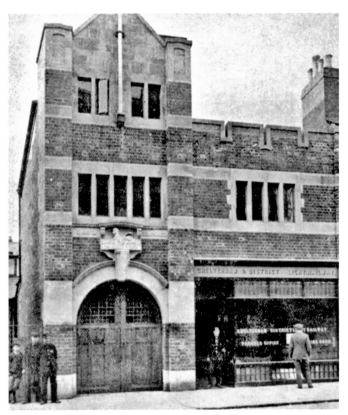

Drill Hall, North Street
Designed by local architect H. T. Rainger for the Gloucestershire Regiment Volunteer Battalion, the Drill Hall in North Street was officially opened in 1906 by Field Marshal Earl Roberts, VC. For the occasion, Roberts stayed with his old comrade Colonel Cunliffe Martin at Delmar in Montpellier Terrace and large crowds lined the route to see the Field Marshall pass by. In 1908, when Lord Roberts again stayed at Delmar, now 81 Montpellier Terrace, he was photographed on the steps with his host, Colonel Cunliffe Martin, in the background. The Drill Hall was demolished many years ago and today the site is covered by the Primark clothing store.

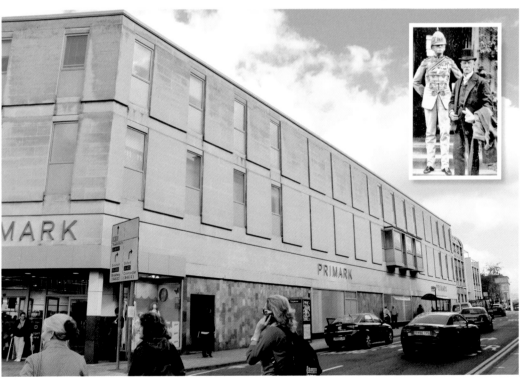

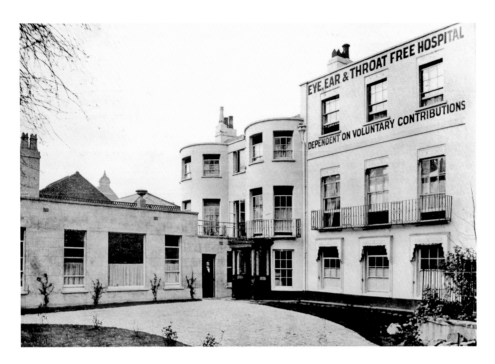

Eye, Ear & Throat Hospital, North Place

Founded at No. 2, North Place, in 1889 by Dr F. A. Smith, the Eye, Ear & Throat Hospital moved across the road to Edmonstone House ten years later. A new wing for outpatients was added in 1908, and further expansion took place in 1911 when another storey was added to the wing on the left, subsuming the furthermost bow on the right. The hospital remained on this site until the mid-1930s, when purpose built wards were added to the General Hospital.

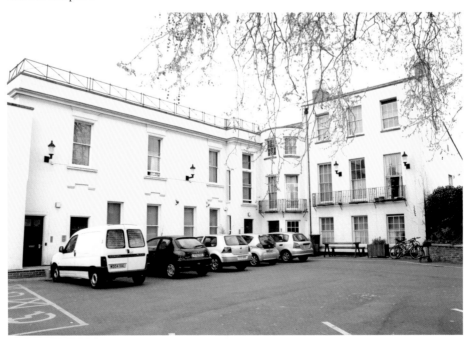

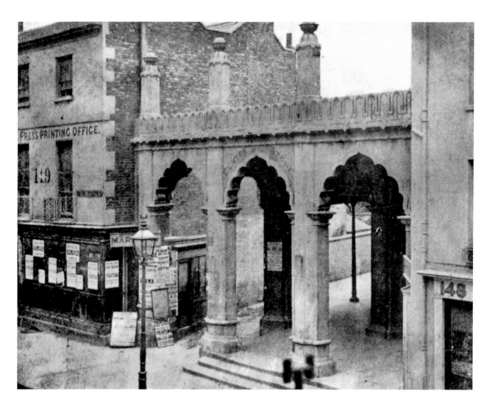

Market, Bennington Street

Photographed probably just before its demolition in 1876, this shows the Mughul Indian style entrance to the market on the site of the present Bennington Street. Just visible are the words 'centre stone', which were replaced by a new stone on the property on the right, as can be seen on the following page. The new photograph shows the weekly market which is held further down Lower High Street.

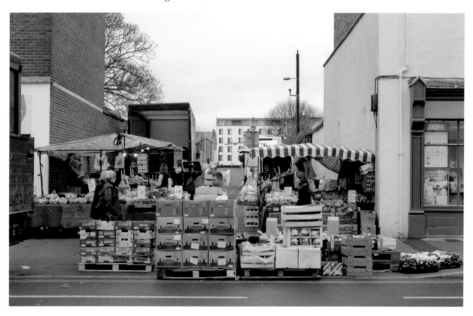

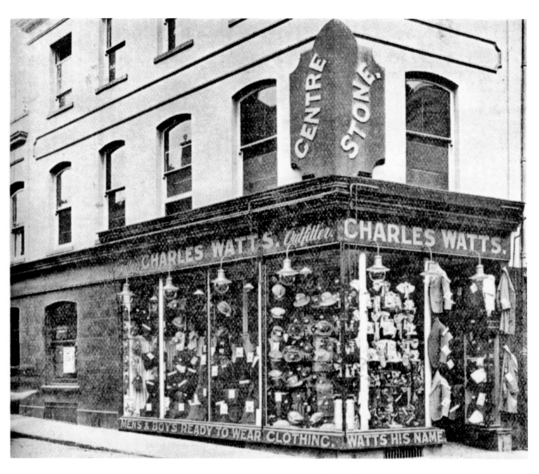

Market, Bennington Street

In 1926, this was occupied by Charles Watts, men's outfitters, and now by a jewellers shop, F. Hinds. In the 1876 photograph, shown on the preceding page, to the left can be seen the offices of one of the town's nineteenth-century newspapers, the *Free Press*.

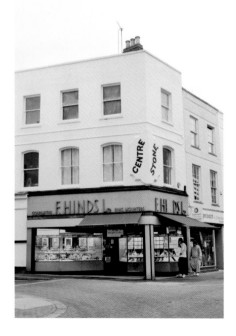

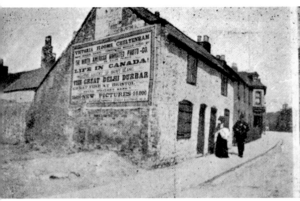
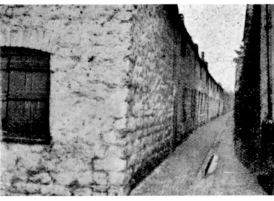

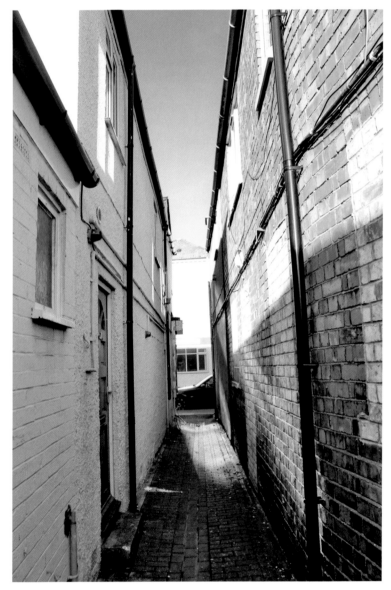

Pantile Row
Described as small and insanitary in 1901, these houses in Pantile Row stood in Elmstone Street, now a cul-de-sac and surely the narrowest street in Cheltenham. It gives access to two properties at the rear of 362 High Street, with the back gardens of the houses in Devonshire Street to the left and waste ground on the right.

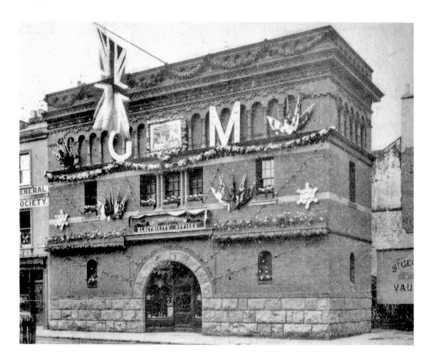

Electricity Offices, Clarence Street

The Cheltenham electricity offices in Manchester Street (now re-numbered as part of Clarence Street) were decorated for the Coronation of King George V and Queen Mary in 1911. Built as the principal sub-station to the electricity works at Arle, the upper stories were added in 1900 and used as offices from 1907 until 1915. A plaque commemorating its use as the town's first and principal sub-station was unveiled in 1986 by the Revd Wilbert Awdry, the author of the *Thomas the Tank Engine* books. The building was converted into an apartment hotel in 2008, its Italianate architecture, reminiscent of a Florentine palazzo, led the owners to name it the Strozzi Palace.

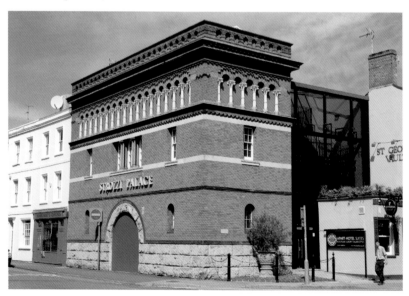

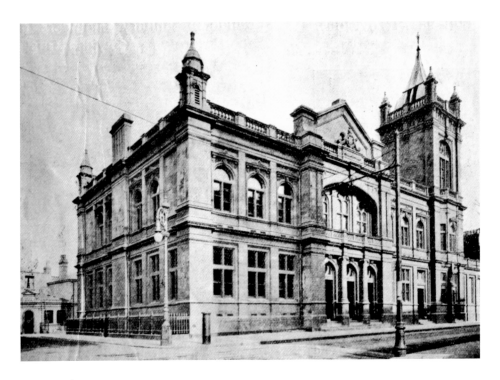

Library, Clarence Street

High and unseen by many passersby, the pediment of the Public Library is surmounted by an 8-foot-high statue of William Shakespeare. The work of G. Hailing, it was the gift in 1911 of R. W. Boulton, head of the local firm of ecclesiastical sculptors. The library opened on this site in 1889; the single-storey art gallery, on the right, was added in 1899 and the museum opened in 1907. Until the reorganisation of local government in 1974, it was administered as one institution under a single head, the Borough Librarian and Curator.

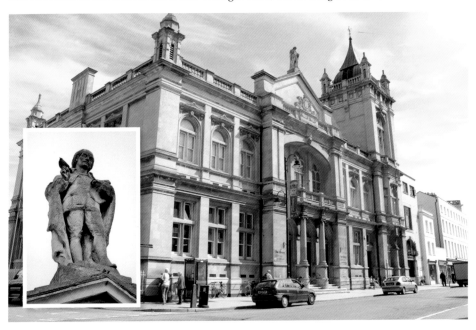

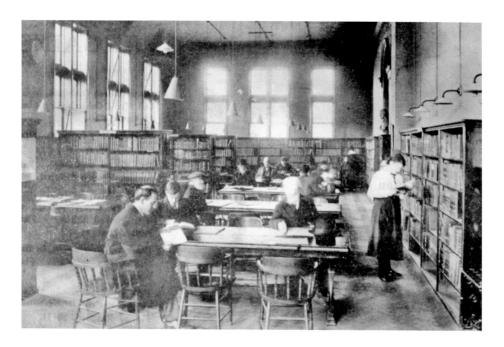

Library, Clarence Street

A reference library was opened in 1918 in the former newspaper reading room, which is shown here. The collections of both library and museum grew, both in quality and quantity, particularly under the stewardship of Daniel Herdman, Librarian and Curator, 1922–50. The art gallery was replaced by a new extension opened by the Princess Royal in 1989, and the museum has continued to expand. Conversely, the library has declined – the reference library has been closed and some of its superb stock auctioned off. Where once the printed word held sway is now the domain of computers, Wii machines and coffee dispensers. Some members of staff can be seen here in the former reference library, now known as the bookroom, when Roger returned in June 2008 to receive a long service certificate. Lynne is seated on the far left.

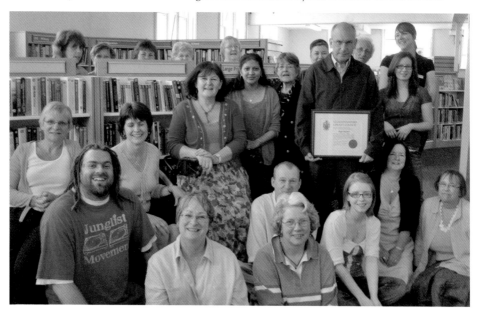

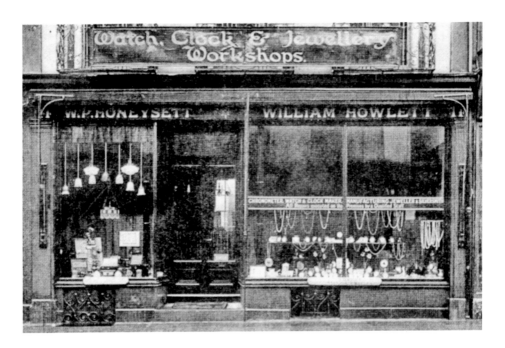

Honeysett & Howlett, Clarence Street

When John Howlett of Bath moved here in 1832, he established a dynasty of skilled and highly respected clockmakers. The family's last retail premises were opened in 1925 at No. 14, Clarence Street. Trading as Honeysett & Howlett, they undertook electrical work as well as watch and clock repairs. By the 1950s the shop looked very old fashioned. The elderly William Honeysett could be seen working on the left side of the shop, while his white haired wife, Lidvine née Howlett, undertook watch repairs on the right. Mrs Honeysett retired in about 1965 and the shop closed about 1969. Its site is covered by the 1970s block known as Cheltenham House. A clock by the Howlett family is in the Mayor's Parlour at the Municipal Offices.

St Matthew's, Clarence Street

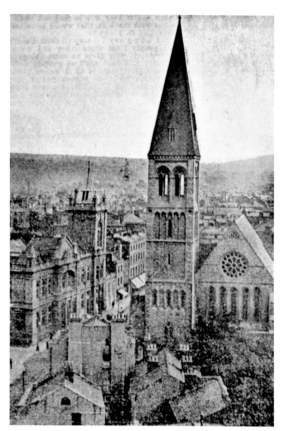

Shown in 1902, St Matthew's in Clarence Street was built as a chapel of ease to the ancient parish church of St Mary's close by. The tower was built in two stages, the lower part in 1877–79, with the spire added in 1883–84. Formerly dominating the skyline, it dwarfed the tower of the Public Library seen on the left. By the early 1950s, the spire had become unsafe and was removed in 1952. Twenty years later concern for its safety led to the removal of the remainder of the tower. Since 1972, when the congregation of Wesley Chapel in St George's Street came to share the building, the space under the tower has been known as the John Wesley Room.

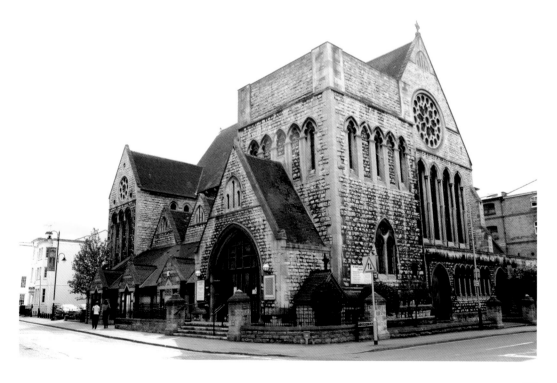

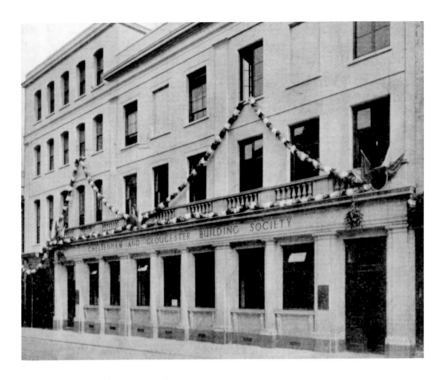

Cheltenham & Gloucester, Clarence Street

In 1850, the Belle Vue Hotel (see pages 49–50) was the venue for a meeting that established what became the Cheltenham & Gloucester Building Society. Seen here is their office in Clarence Street in 1907, and as extended and rebuilt twenty-eight years later. The Society continued to expand both locally and nationally until, by the 1970s, much larger premises were needed.

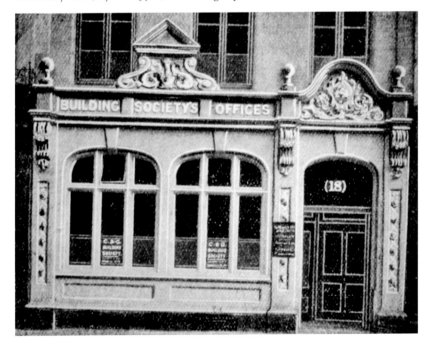

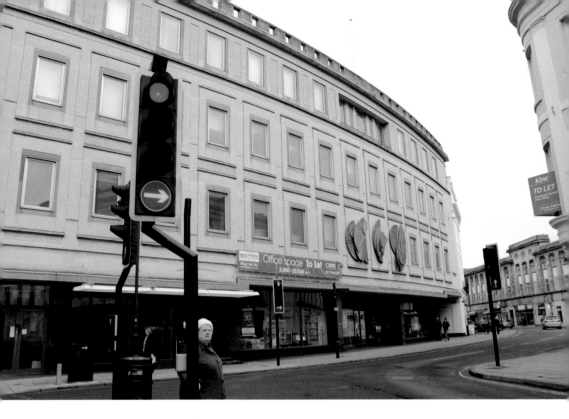

Cheltenham & Gloucester, Clarence Street

Seen here is the modern building which was completed in 1975 and prosaically named Cheltenham House; even this became inadequate and a new HQ was built at Barnwood, near Gloucester. The Society, now part of Lloyds Bank, was not permitted to remove the sculpture they had commissioned by Barbara Hepworth and it stills adorns their former Clarence Street premises.

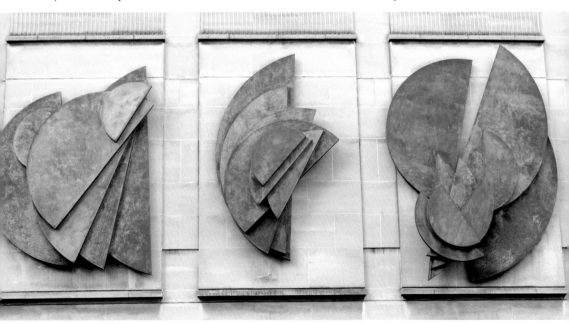

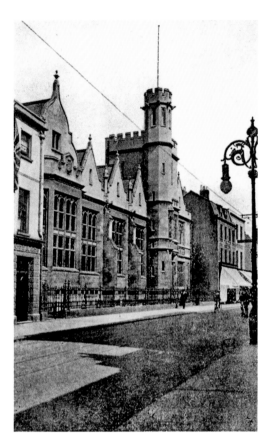

Grammar School, High Street
Re-built in 1887–89 in Tudor Gothic style, the boys' Grammar School had stood on this site since 1572, when it had been founded by Richard Pate with a grant from Queen Elizabeth I. Alumni include the composer Gustav Holst, parson poet R. S. Hawker, Frederick Handley Page, aeronautical engineer, and Benjamin Baker, civil engineer and designer of the Forth Rail Bridge.

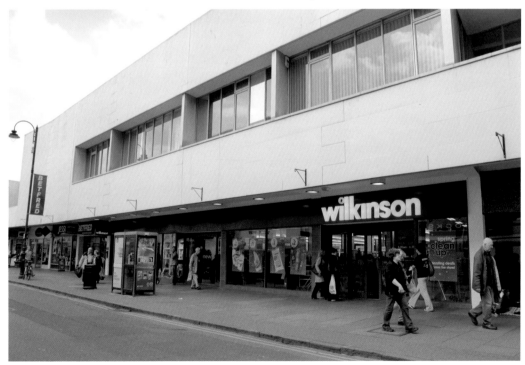

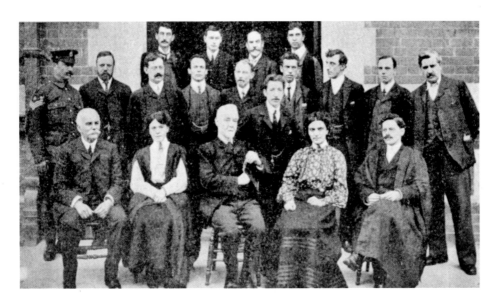

Grammar School, High Street
The above image shows the staff of 1906: back row – W. Oldland, F. Cavanagh, G. Fenning, H. White; middle row – Sgt Barrow, A. Hudson, F. Brock, F. Mason, E. Kilminster, W. Stockings, F. Broad, R. Baron, J. Oakey; bottom row – C. Stuart Millard, S. Evans, F. Fletcher, H. Carrick, E. Wilkins, H. Robjohns. The school moved to a new site at Hesters Way in 1965, and has since become co-educational. Its existence here is marked by a small plaque outside the Wilkinsons store in the clumsy 1960s block that has replaced it. The Victorian statue of Richard Pate that formerly adorned the façade of the High Street building has been relocated to the present school.

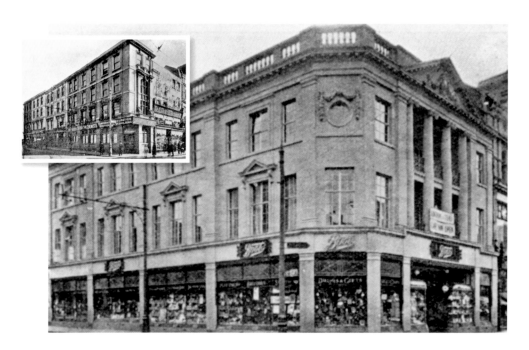

Boots, High Street

In 1924, Boots the chemists announced plans to completely rebuild their premises at the corner of North Street and High Street. The imposing, pedimented new building opened in 1927 and offered, as well as medical and surgical requirements, a café, a subscription library, an art gallery and a book department. The inset photograph shows the shop prior to the rebuild.

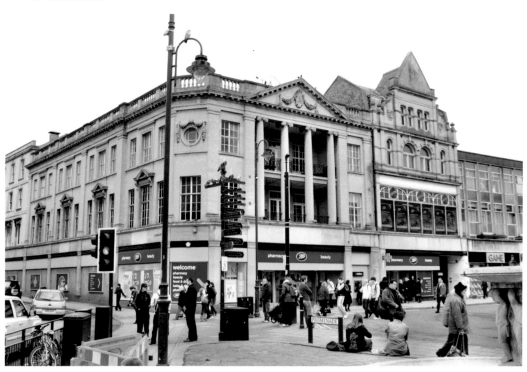

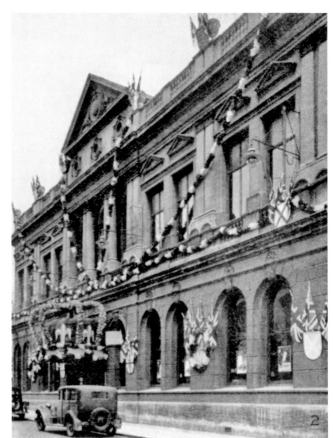

Boots, High Street
Also shown, as decorated for the Coronation of King George VI in 1937, are the late Victorian Gas Offices situated at the corner of North Street and Albion Street. Demolished around 1962 and replaced by a furniture store, that building has since been incorporated in to the expanded Boots, sadly now without its café and library.

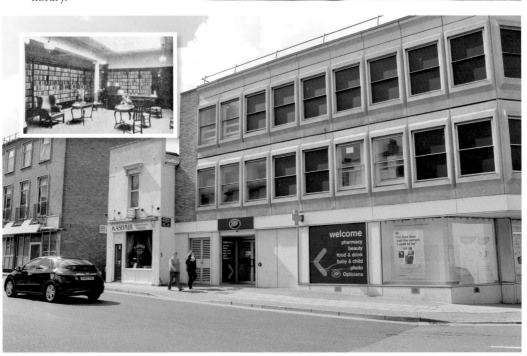

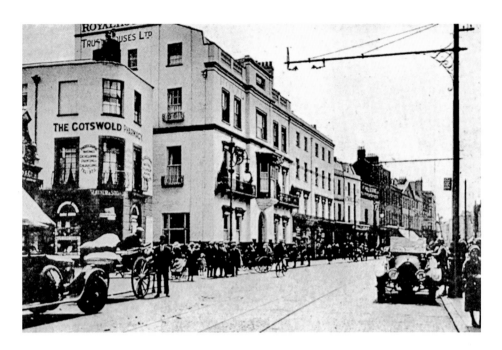

Royal Hotel, High Street

Built on the site of the house of John de la Bere, the town's chief magistrate who died in 1795, the Royal was one of several hotels and inns in the High Street that survived into the twentieth century. Shown here about 1925, it was little altered from its Regency appearance. During the early 1950s, a uniformed commissionaire stood outside the entrance, but by the end of the decade the hotel had been replaced by a huge Woolworth's store. This in turn was replaced by the £35 million Beechwood Place shopping arcade that opened in March 1991. The building housing the Cotswold Pharmacy, though extended, is still recognisable and is now a dental and optical centre.

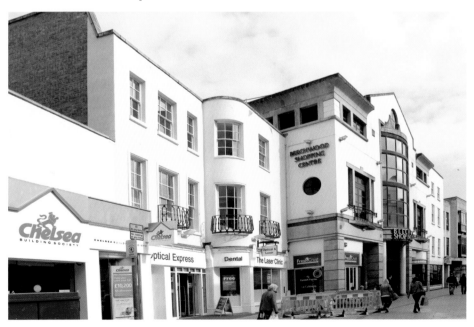

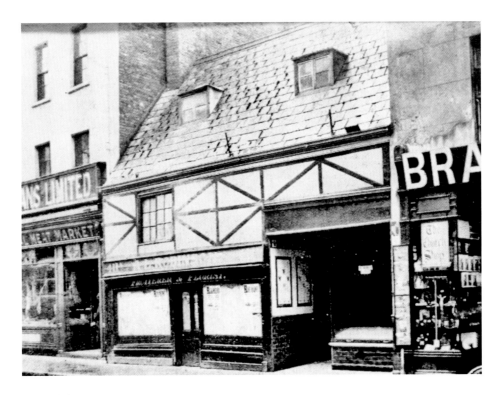

411a High Street

Due to be demolished in 1924, the building, occupied for many years as a greengrocers and fruiterers at 411a High Street, was described as 'one of the last of the old fashioned, low ceiling shops'. Standing in the part known as the Strand and since renumbered 82 and 84 High Street, the present undistinguished building houses a pizza shop and jewellers on the ground floor, with a hairdressers above.

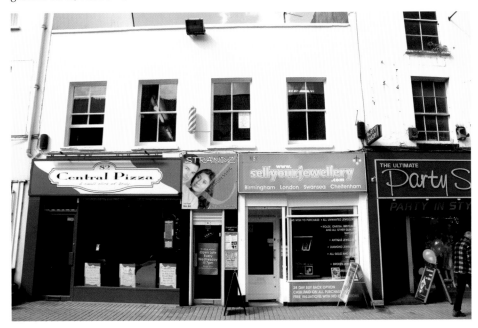

THE
MASTER OF THE CEREMONIES' BALL
WILL BE AT THE
ASSEMBLY ROOMS,
On MONDAY, SEPTEMBER the 29th, 1834.
Tickets to be had of Mr. MARSHALL, Harley Place, Rodney Terrace; at
the Montpellier Rotunda, and at the Assembly Rooms.

ASSEMBLY ROOMS, CHELTENHAM.

THE ANNUAL JUVENILE BALL
WILL TAKE PLACE
On WEDNESDAY NEXT, JANUARY 17th,
Commencing at 8·30 p.m., terminating at 2 a.m. Juveniles have precedence until 11 p.m.

Stewards—Col. CODDINGTON, T. ROME, Esq., J. H. LOCKE-JONES, Esq., R. CRAIGIE HAMILTON,
Esq., and C. C. TURNBULL, Esq.

The Committee will meet at the Rooms from 12 to 1 mid-day, and from 3 to 4 p.m. on the
day of the Ball, for the purpose of issuing Tickets. Non-Subscribers' Tickets, 7s.; Juveniles
(under 14 years of age), 3s. 6d.

The Orchestra will be under the Direction of Mr. P. JONES.

ASSEMBLY ROOMS, CHELTENHAM.

TWO GRAND PROMENADE
CAFÉS CHANTANTS,
INCLUDING
Variety Entertainments and Refreshments,
On SATURDAY, JANUARY 27th,
In Aid of the War Fund for Officers' Widows and Families,
Doors open at 3 p.m. and 8 p.m.

Tickets, Four Shillings each inclusive, if taken before January 25th, after which date Five
Shillings, can be obtained at BANKS' Imperial Library, Cheltenham.

MISS
CLARA BUTT'S
GRAND EVENING CONCERT,
MONDAY, JANUARY 29th,
AT THE ASSEMBLY ROOMS.

Tickets now ready at DALE, FORTY & Co.'s Pianoforte Galleries.

Assembly Rooms, High Street
Shown here is a print of 1856
of the Assembly Rooms, which
stood at the corner of the High
Street and Rodney Road. Opened
by the Duke and Duchess of
Wellington in 1816, they were the
centre of the town's social life
hosting balls, concerts, lectures
and other activities. They were
demolished in 1900 when the
new Town Hall took over many
of the Rooms' functions. The
adverts, from *The Looker On*,
the society weekly paper, are
advertising a ball in 1834 and a
variety of events in January 1900.

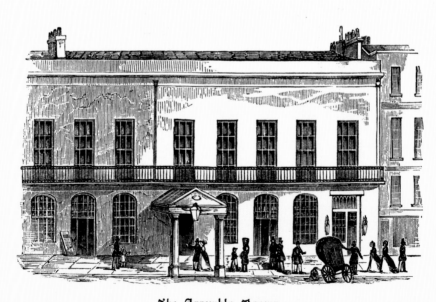

The Assembly Rooms.

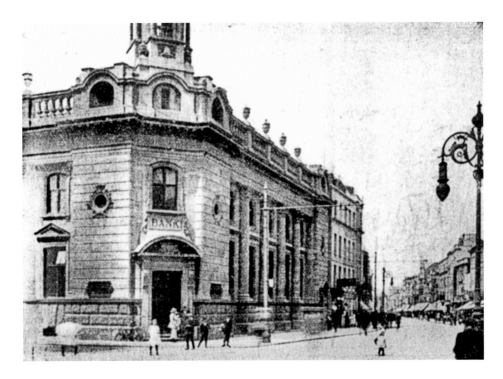

Assembly Rooms, High Street

On the site Waller & Son, also architects of the Town Hall, designed a neo-Baroque building for Lloyds Bank, whose new banking hall (though described by one writer as 'somewhat ponderous') looks as if it could be an assembly room itself! Note the tram standard outside the bank in the photograph of 1917. In addition, note the 'Dragon and Onion' lamp stand, examples of which can still be seen in the town, notably in the parish churchyard.

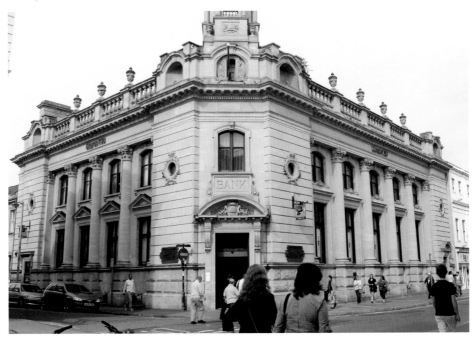

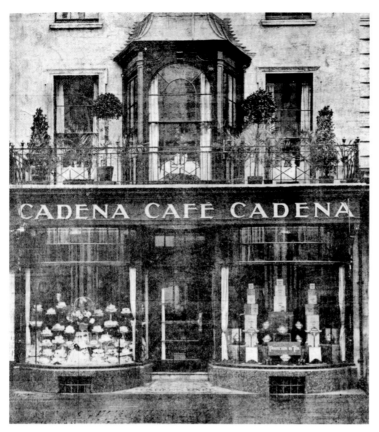

Cadena Café, High Street
Photographed in 1921, after being completely refitted, is the Cadena Café at No. 126, High Street. Known as the Oriental, it had been acquired in 1919, together with the Cosy Corner in the Promenade, by Cadena Cafés Ltd from E. E. Marfell. For many years the upper room was the venue for wedding breakfasts and other happy occasions, while passersby would be drawn by the aroma of roasting coffee beans. The café has long been absorbed by the neighbouring branch of Barclays Bank.

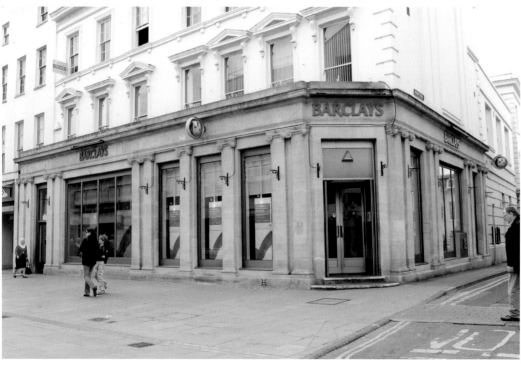

Coopers Arms, High Street

Almost totally destroyed by fire in 1909, the Coopers Arms in the High Street was rebuilt by the owners, the Original Brewery, in some style. Green glazed tiles bear the raised lettering 'Ales & Stout' and 'Wines and Spirits'. Above the centre door is a ceramic plaque, one of the many once common in the town, bearing the legend 'West Country Ales Best in the West'. Renamed Cactus Jacks in the late 1980s, it is today the Vine, more of a wine bar than pub, and has expanded to include buildings at the rear in St James's Street.

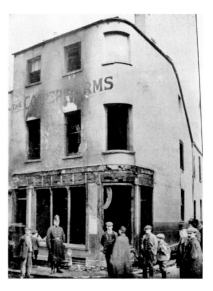

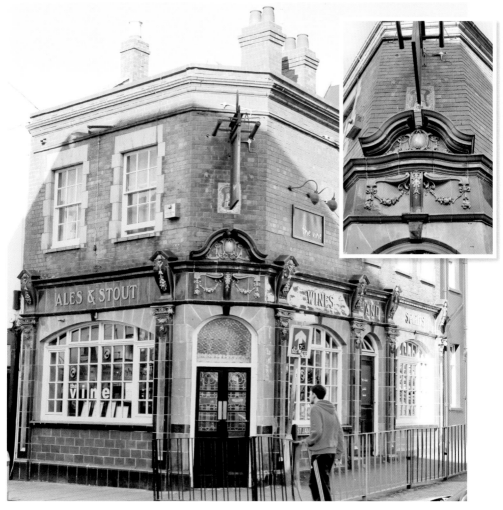

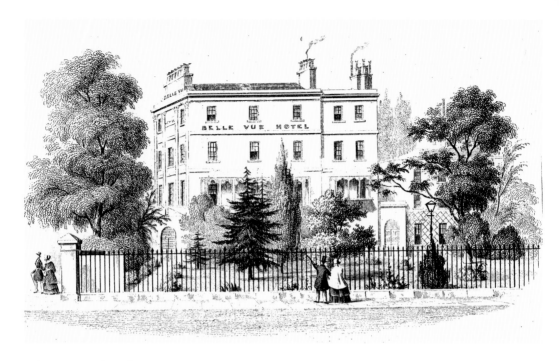

Belle Vue Hotel, High Street

Built before 1800 as the town house of the Hicks-Beach family, the Belle Vue Hotel was altered and enlarged early in the nineteenth century. Illustrated here in an engraving from one of the town guides dated 1845, it was one of the leading hotels in the town. Renamed the Berkeley Hotel in the 1960s, it was acquired by Sir Charles Irving, sometime Mayor and MP for the town and became the Irving Hotel in the 1970s. His family had formerly owned a hotel of the same name in Bath Road. Today, much extended, it has been converted into flats known as Irving Court.

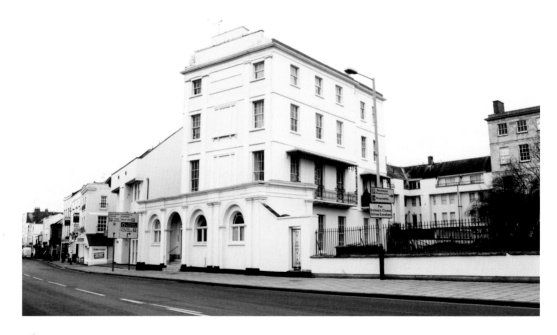

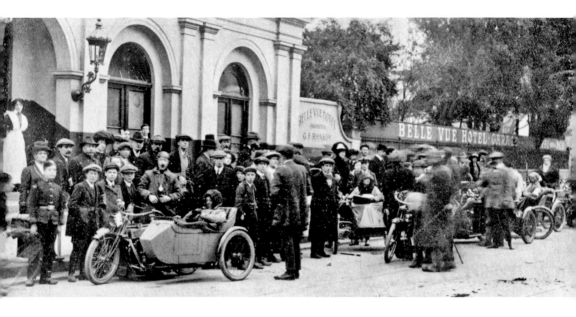

Belle Vue Hotel, High Street

Shown here meeting in 1913, outside the Belle Vue Hotel, the headquarters of the Cheltenham Motor Cycling Club, is the start of the Reliability Trial. The trial was for sidecars and at the front of the line is one of the winners, Mr Gibbs, with his wife in the sidecar. Joint winners, Messrs Smith and Gibbs, tied after making nonstop runs and only 29 seconds out on time allowance!

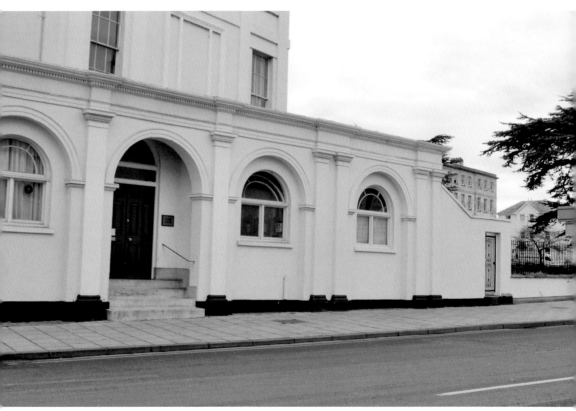

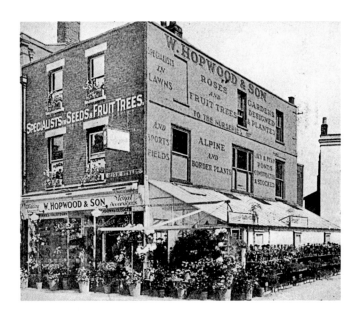

Hopwood's, High Street

Formerly the town's leading garden nurserymen, Hopwoods were established by William Hopwood, sometime Head Gardener to Earl Bathurst at Cirencester. His first nursery in Hewlett Road was later joined by another in Prestbury Road and, in 1886, a shop and glasshouses in the High Street, adjoining the Belle Vue Hotel. This photograph shows the shop and Belle Vue Nursery in 1938. The site of the Hewlett Road nursery has long been developed, while the one in Prestbury Road lies vacant and, at present, the subject of controversial development plans. In the High Street the site of the Belle Vue Nursery has become an extension to Irving Court, while the former shop is occupied by a home cinema dealer.

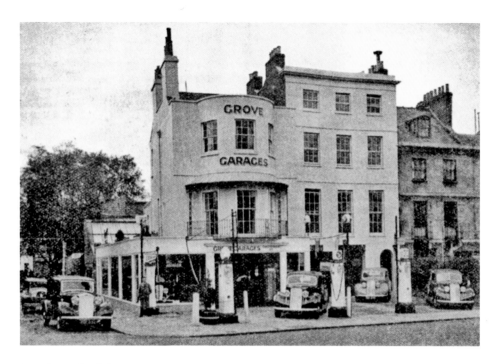

Sunningend, High Street

Originally an elegant Regency villa, Sunningend, at the corner of College Road and High Street, became, in 1888, the workshops and showrooms of H. H. Martyn. The company became one of the leading producers of architectural carving in wood, stone and metal, and a plaque on the building now commemorates their occupation. Sunningend is shown here in 1936 as Grove Garage complete with petrol pumps. Older residents will remember the building as the Rolls-Royce showrooms of Messrs Broughton. Now known as Stirling Court, it has been skilfully converted into offices.

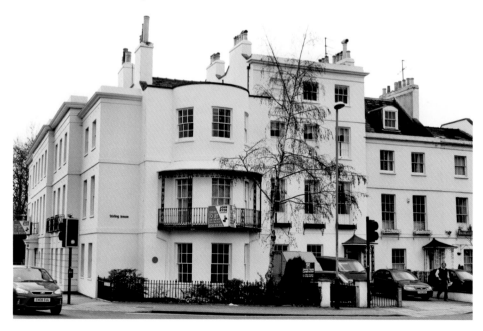

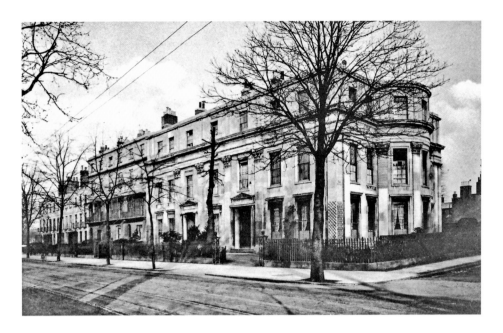

The Priory

Built to a Greek Revival design in the 1820s, the Priory was originally two houses, Priory House to the left and the Priory to the right. The Master of the Ceremonies, Charles Marshall, lived at the Priory and entertained the Duke of Wellington here in August 1828. By 1959, the house was redundant as a hostel and was placed on the market. Its proposed demolition in 1961 brought forth a flurry of protests, but the building continued to decay and was demolished in 1968. It was replaced by an office block, Mercian House, which in 1999 was replaced by Wellington Mansions, a block of flats whose design echoes that of the original building. A plaque on the building commemorates the fact that the social reformer Josephine Butler lived at the Priory, while her husband was a master at Cheltenham College.

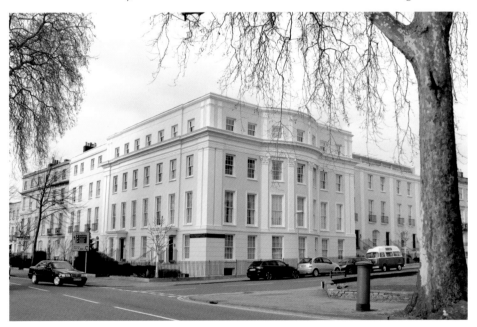

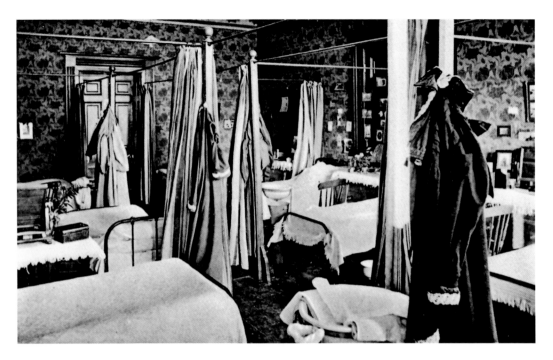

The Priory

These postcards show the Priory when used as a hostel by trainee women teachers from St Mary's College. Note how the dormitory is so different from today's student accommodation. The only privacy is the curtain that pulls around the bed!

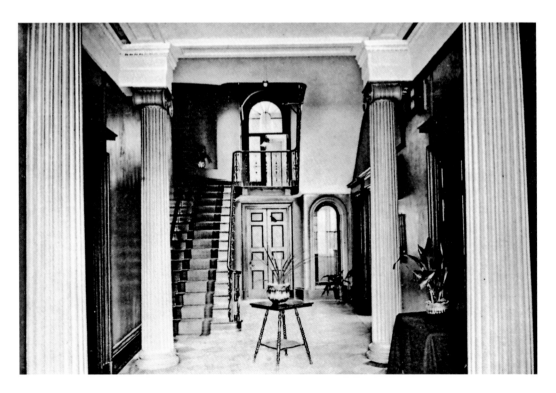

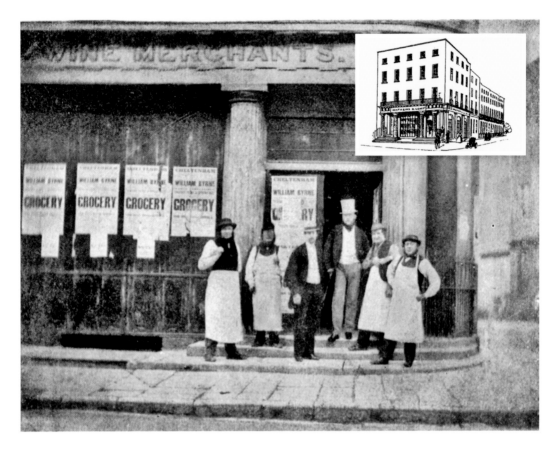

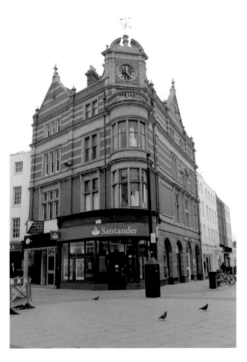

White Brothers Wine Merchants, Cambray
Standing at the corner of High Street and
Cambray Place, this imposing building, with
its Greek Doric columns, is shown in George
Rowe's guide of 1845 (inset) as occupied by
Mathews & Co., grocers. Later occupied by the
London Supply Co., the photograph shows
auctioneers outside the building, which was
demolished about 1906. Replaced by the present
red-brick building now housing a branch of the
Spanish bank Santander, older residents will
recall the popular Clock Restaurant there run
by the Chrisanthou family.

Turkish Baths, Cambray

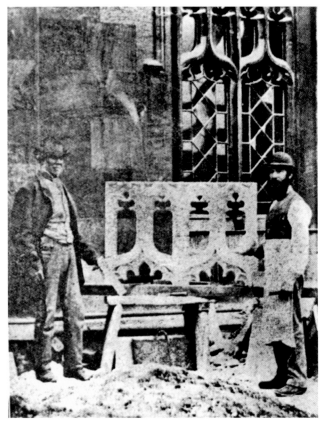

The octagonal Cambray Spa, built in 1834 by Baynham Jones of nearby Cambray House, stood at the corner of Rodney Road and Oriel Road. It was converted to a Turkish Baths in 1873, and this photograph shows William Brown (on right) of Tivoli, and his father working on the conversion. Brown also worked as a sculptor on the Houses of Parliament and was responsible for many of the caryatides in Montpellier Walk. The baths were demolished to make way for the present car park in 1938.

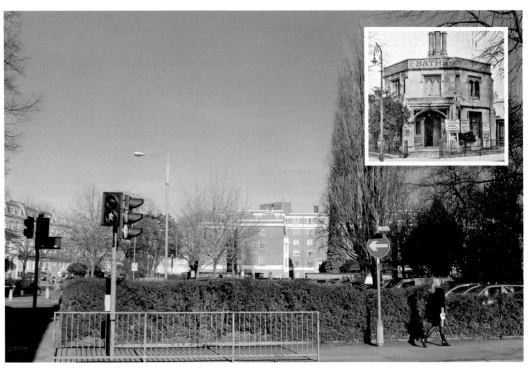

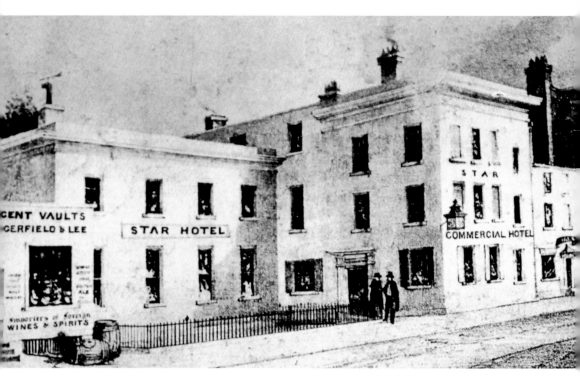

Star Hotel, Regent Street

In continuous use as a public house since the 1820s, the Star Hotel in Regent Street is shown here in 1838, when the landlord was William Dangerfield. Today it is known as Copa, but the Star will be remembered by many as the Berni Inn, popular for family meals.

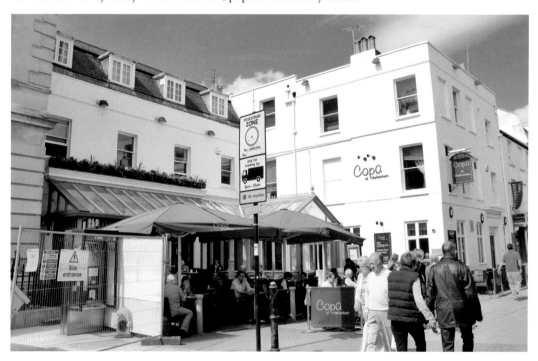

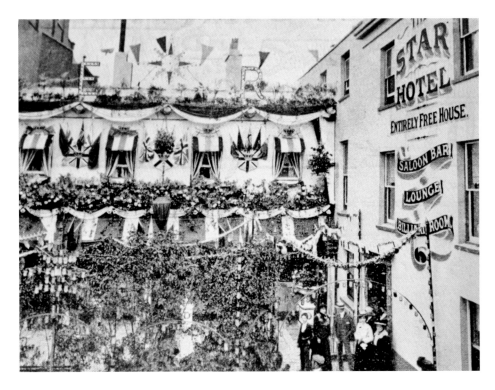

Star Hotel, Regent Street
The Star Hotel shown again sixty-four years later, while decorated for the Coronation of King Edward VII. The building had altered little, though the Regent Vaults on the left had been replaced by the County Court in 1868–1870. The redundant County Court building itself awaits conversion to a restaurant for celebrity chef Jamie Oliver.

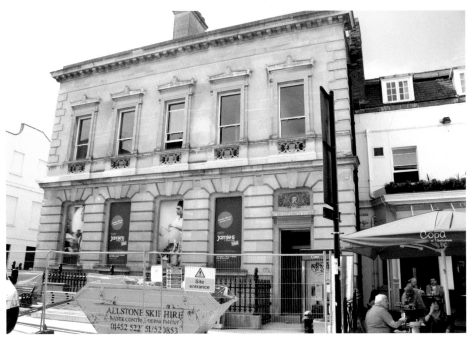

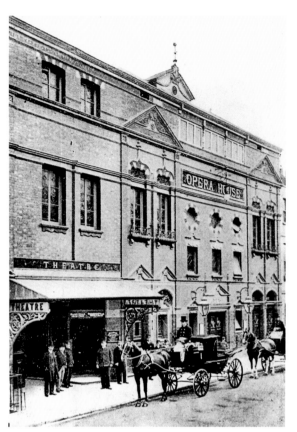

Everyman Theatre, Regent Street
Opened on 1 October 1891 by no
less a figure than Lillie Langtry,
'the Jersey Lily', the Opera House in
Regent Street was designed by the
leading theatre architect of the day,
Frank Matcham. Seen here about
1910, its undistinguished façade
gives no clue to the riches inside, the
ornate plasterwork of which has been
described as the 'splendidly sugary
rococo interior'. A touring theatre,
many of the great players of the past
have appeared here from Little Tich
and Ellen Terry, to Edith Evans and
John Gielgud. Renamed the Everyman
in 1960 the present façade dates from
the 1980s. A small plaque, placed
here by the Frank Matcham Society,
records the fact that this is now one
of his earliest surviving buildings.

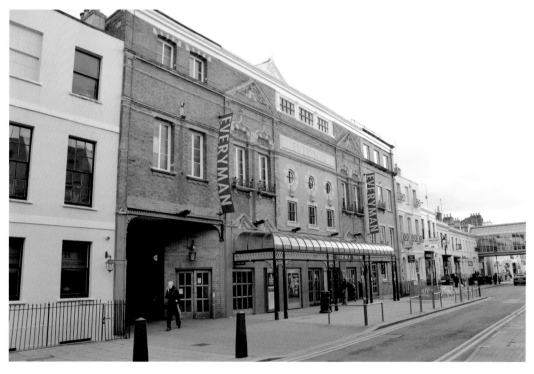

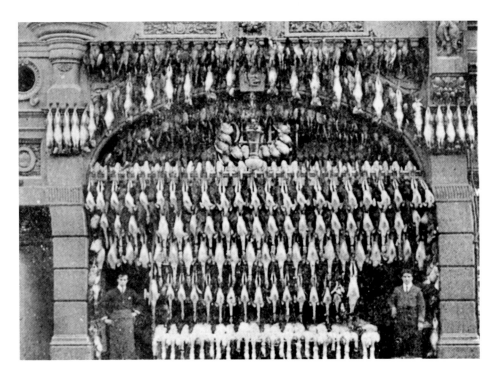

Olive & Olive, The Colonnade

The 1911 Christmas show of Olive & Olive, fishmongers and poulterers, at their premises in the Colonnade now renumbered as part of the Promenade. Established in 1819, they were the principal game bird dealers in the town, but modern food safety regulations would surely forbid such a display, open to the dust and fumes of the road, today! Olives' shop has long been incorporated into the premises of HSBC, formerly the Midland Bank; but how many passersby notice the carving of game birds still to be seen to the left of Hooper Bolton's premises?

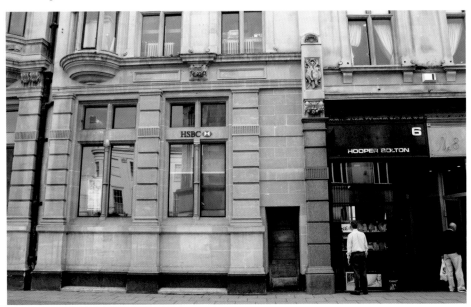

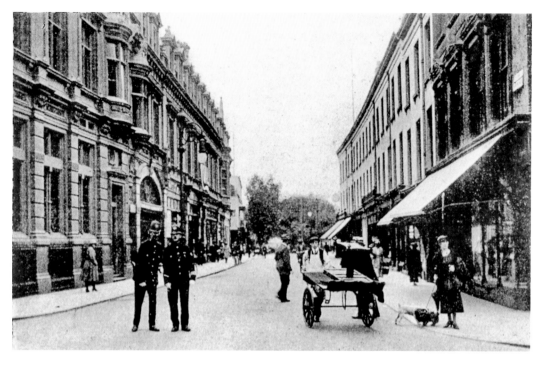

The Colonnade

The Colonnade, *c.* 1923, now renumbered as part of the Promenade, has its origins in a row of shops built in the 1790s. The left side was redeveloped a century later, but the right side not until the 1930s. Many of the units were occupied by the long established department store Shirer & Haddon, who had been appointed mercers, lacemen and drapers to Queen Victoria in 1838.

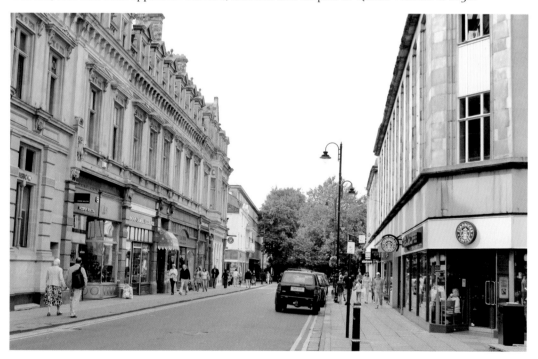

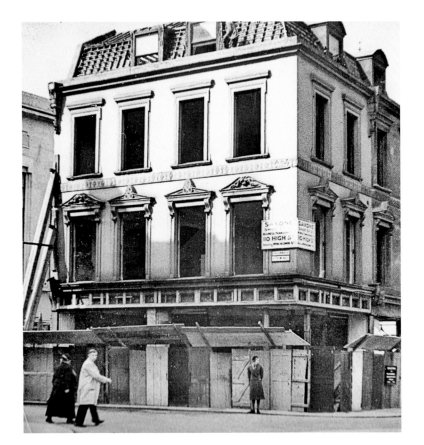

The Colonnade
This photograph shows the former Saxone Shoe Company premises before demolition in April 1937. Now, where customers once tried on shoes, are the pavement and a small concreted area with fountain.

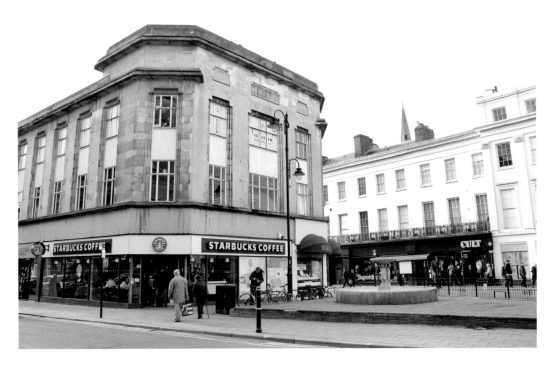

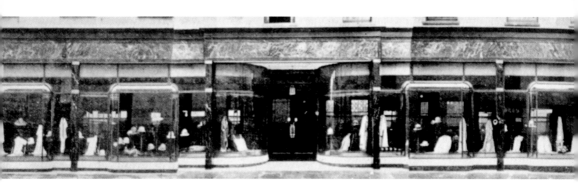

Madame Wright's, Ormond Place

Modelled on a shop she had seen in Paris, the costumier Madame Wright opened these new premises in Ormond Place (which she renamed Little Promenade) in 1925. Attracting an exclusive clientele, Madame Wright's customers included Queen Victoria's granddaughter, Princess Marie Louise, who bought her outfit here for our present Queen's wedding in 1947. The BBC used the exterior in 1991 for their television series *The House of Elliott*, but following the death of Madame Wright's son in 1995 the business closed. Today the building houses a hairdresser and a unisex shoe and clothing retailer. The former workrooms on the upper storey have been converted into flats.

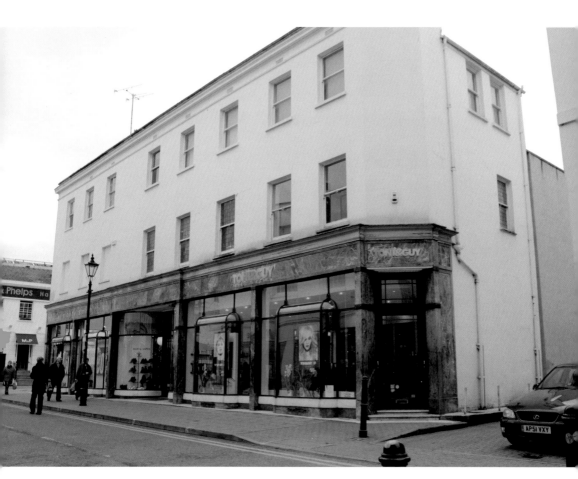

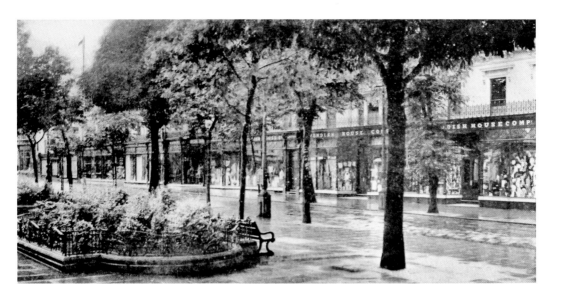

Cavendish House, Promenade

The early nineteenth-century façade of Cavendish House, the town's leading department store, shown here in the mid-1920s. Though its advertisements claimed the store had been founded in 1818, the first small shop had been opened in 1826 by Clark and Debenham from London, selling silks, muslins, lace and shawls. In the now pedestrianised Promenade, the bland exterior of the completely rebuilt Cavendish House was designed in the 1960s by Downton and Hurst of London, destroying the character and charm of the nineteenth-century store, though local opposition to renaming the shop have so far been successful.

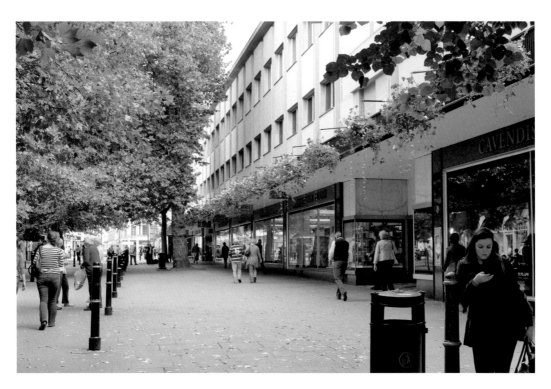

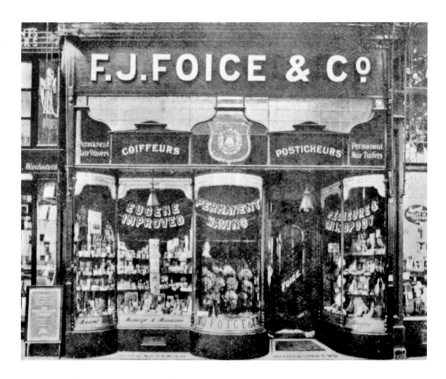

Foice Hairdressers, Promenade

For over sixty years Foice's in the Promenade was the leading hairdresser in the town. Opened by F. J. Foice in July 1901 at 20 (now 94) Promenade, he originally employed three assistants. By 1926, twenty-five people were employed in the ladies', men's, children's and postiche (hairpiece) departments with manicures and pedicures also being available. In that year, the shop was completely rebuilt with a new façade to the Promenade and a new wing and entrance in Regent Street. Foice's closed about 1967 and today their premises are occupied by the women's fashion store, East.

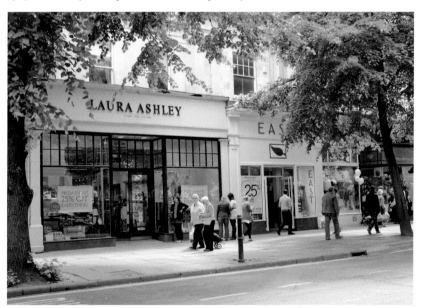

Foice Hairdressers, Promenade
Foice hairdressers were a fashionable choice for many in Cheltenham. These three images show the office, the postiche department and the children's department.

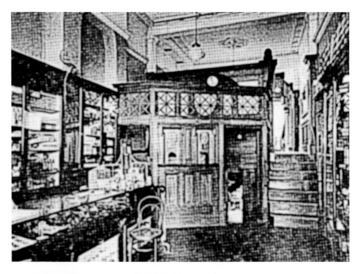

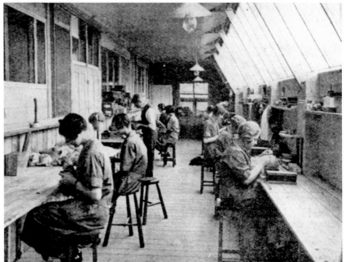

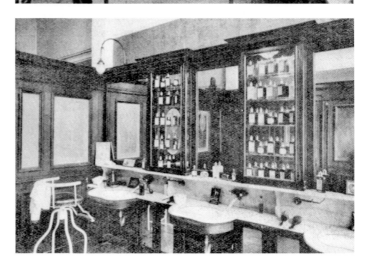

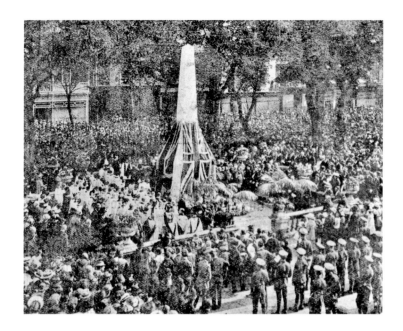

War Memorial

With the end of the Great War in 1918, there was a movement throughout the country to commemorate those who had died in 'the war to end all wars'. In Cheltenham, several grandiose schemes had to be abandoned due to lack of funds. Eventually a simple obelisk, 24 feet high and inscribed with the names of the fallen, was erected by R. L. Boulton and Sons. Placed immediately in front of the Municipal Offices, the memorial was unveiled by General Sir Robert Fanshawe on 1 October 1921. Following the end of the Second World War, bronze plaques listing those killed in that conflict were unveiled on 12 November 1950 by General Lord Ismay. Further memorials have been placed around the obelisk in memory of those killed in later wars and campaigns. They include a plaque to Daniel Beak, VC, sometime of the local YMCA, who rose from the ranks to become a Major General.

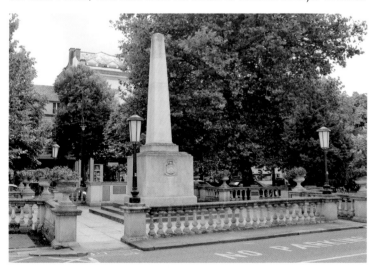

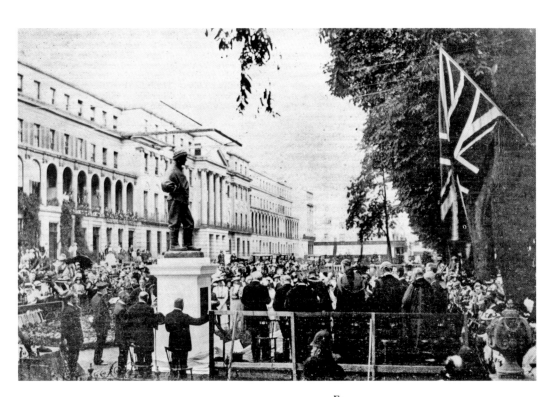

Edward Wilson, Promenade

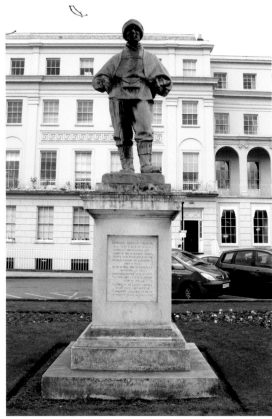

Born at a house in Montpellier Terrace, Edward Adrian Wilson accompanied Scott on his two Antarctic expeditions and died with him on their return from the South Pole. This view shows the unveiling of Wilson's statue in the Promenade Long Gardens in July 1914, an event attended by Wilson's widow and parents, and many of his family and friends. The statue was carved, appropriately, by Scott's widow and cast in bronze by the local firm of R. L. Boulton's. On the statue's plinth are carved Scott's words, 'He died as he lived. A brave true man. The best of comrades and staunchest of friends.'

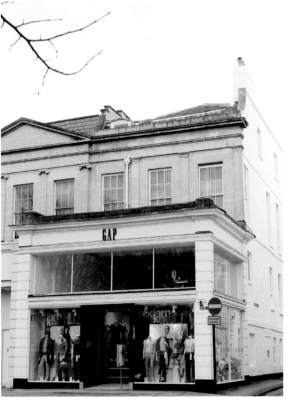

Dale, Forty & Co. Ltd, Promenade
During the first part of the twentieth century, Dale, Forty & Co. were the leading retailers of pianos in the town. Their story began in 1873 when Frank Forty and Henry Dale, a piano tuner with Broadwoods, were taken into partnership by a music dealer named Finlayson. A public company since 1912, this shows their premises at No. 24, Promenade Villas, at the corner of Imperial Lane. When the company ceased trading in the mid-1950s, the premises were occupied by a furniture retailer, but today, where once pianos tinkled, cash registers now ring for the sale of women's clothing.

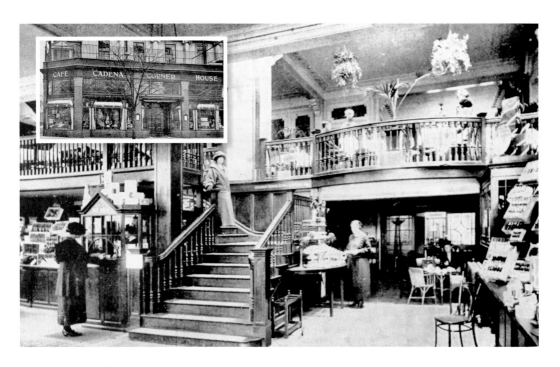

Cadena Café, Promenade

Shown here in 1923, after being completely refitted, is the Cadena Café in the Promenade. Occupying the lower floors of Belgrave House, whose handsome entrance can still be seen around the corner in Imperial Square, it was originally a boarding house for fashionable visitors to the Spa. In 1919, Cadena Cafés Ltd took over Mr E. E. Marfell's Cosy Corner café and immediately applied for a music licence allowing those partaking of morning coffee, luncheon or afternoon tea, to be entertained by a trio. Today the former Cadena premises house three retailers of high quality fashion.

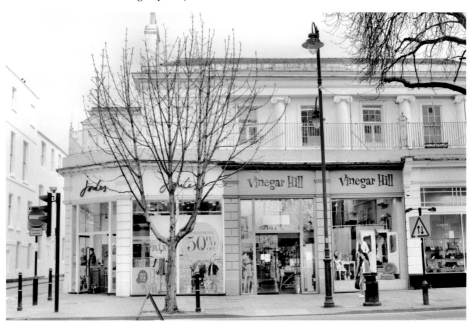

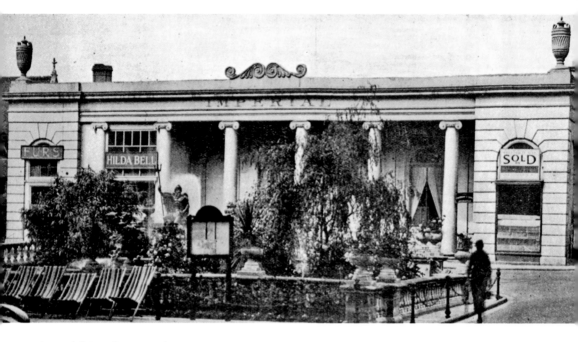

Imperial Spa, Promenade

The Sherborne or Imperial Spa stood at the head of the Promenade which was the area for visitors to exercise by 'promenading' for the waters to take effect. With the building of the Queen's Hotel, the spa building was re-erected as the Imperial Rooms at the corner of St George's Road. Using water from the underground River Chelt, the Neptune fountain was added in 1893; the Borough Surveyor was said to have drawn his inspiration from the Trevi Fountain in Rome. The rooms are shown here in September 1937, immediately prior to their demolition to make way for the Regal Cinema.

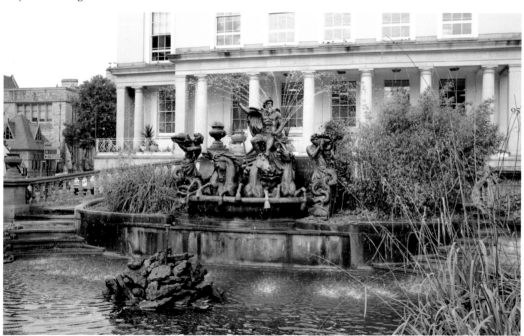

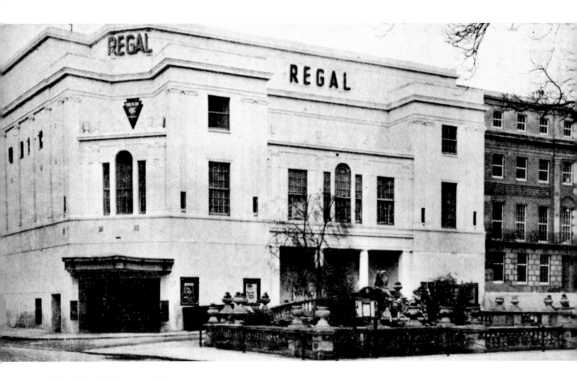

The Regal, Promenade

The Regal opened with the showing of *The Adventures of Robin Hood* starring Errol Flynn. The self-effacing exterior offered no clue to the glory of the plasterwork inside, the work of the local firm of H. H. Martyn & Co. Later known as the ABC, when the cinema in turn was demolished for the present Royscot House to be built, a section of the plasterwork was preserved by the town museum.

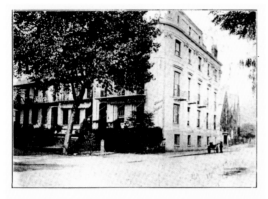

∴ Tate's Private Hotel ∴

CHELTENHAM SPA.

Established 1890

Excellent Cuisine—Rooms pleasant and airy—Sanitary arrangements perfect—Within five minutes' walk the Town Hall, Central Spa, Ladies' College, Theatre and Opera House, New Club, Promenade, G.P.O., Parish Church, and within easy distance of the Railway Station.

+☰✠☲+

The Hotel is under the personal management of the Proprietor—
Mr. T. R. TATE.

Wires : "TATE'S CHELTENHAM" *Telephone :* **949**

Tate's, Promenade Terrace
In 1890 Thomas Tate, once employed as a butler in Liverpool, opened No. 1 Promenade Terrace as a boarding house, and by 1901 Tate's private hotel had expanded into the adjoining numbers 2, 3 and 4 in the terrace.

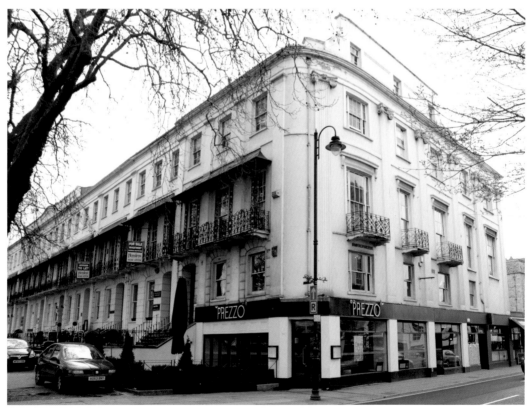

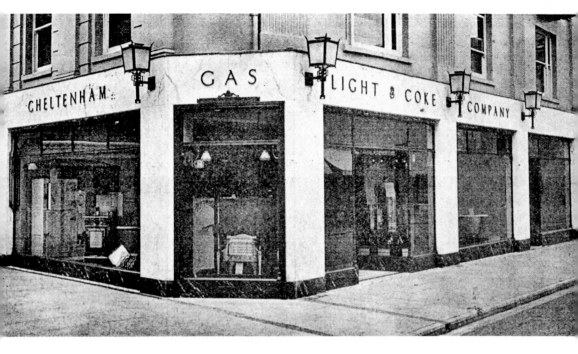

Gas Showrooms, Promenade Terrace

Change came in 1927 when the ground floor of No. 1, Promenade Terrace, was transformed into a showroom for the Gas, Light & Coke Co., and given the number 40, Promenade, as shown in these two photographs. The ground floor façade was covered in white Sicilian and black Napoleon marble, though the hotel continued to occupy the upper storeys. Today the ground floor is occupied by an Italian restaurant and the former hotel premises by a number of other businesses.

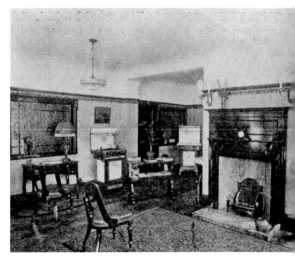

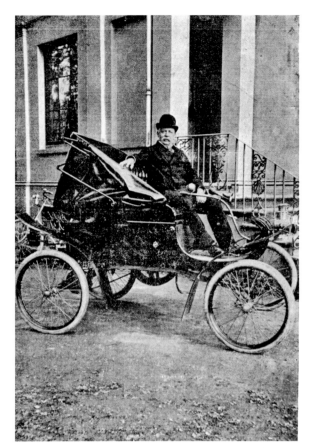

Clarence House, Promenade
The first registered car in Gloucestershire, shown here in 1903 with its owner Horatio Fernald, outside his home, Clarence House, in the Promenade. An American citizen born in Maine, Dr Fernald practised as a surgeon dentist and was President of the Cheltenham and County Automobile Club. Could he ever have envisaged how, in the future, traffic would constantly roar past his former home, now converted into offices? Or how his great interest and hobby would totally change our landscape?

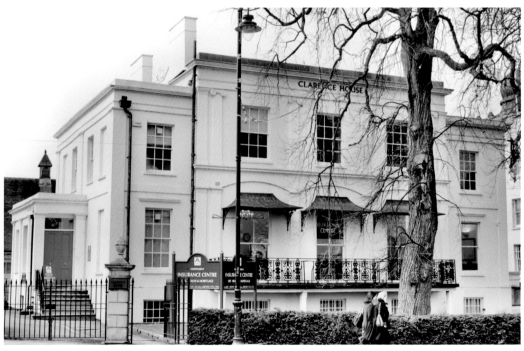

Lansdown Fountain

The drinking fountain at Westal Green was the gift of the three Misses Whish of Lansdown Place, the daughters of a clergyman. Erected in 1901, it was designed and carved by the ecclesiastical sculptor A. B. Wall of Whaddon Road and was removed in 1929 to its present home in Sandford Park, where its truncated remains can still be seen. Today surrounded by the constant traffic of Lansdown Road, Westal Green is the site of a petrol station and a classical building housing an electrical sub-station.

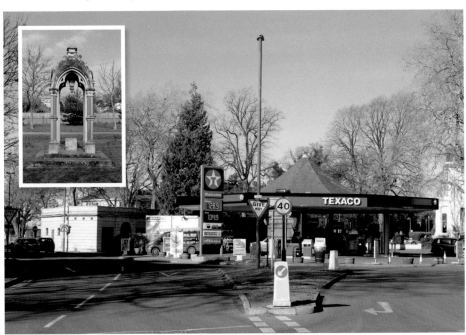

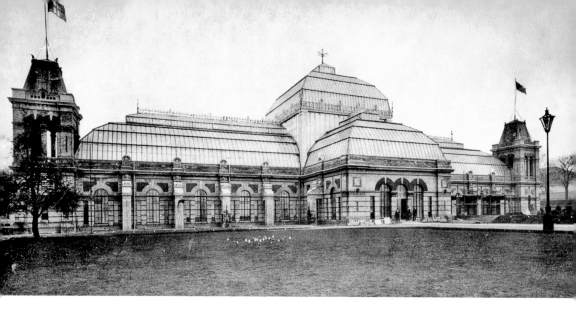

Winter Gardens

Cheltenham's own Crystal Palace, the Winter Garden, opened in 1878, providing a multipurpose venue for circuses, exhibitions, balls, roller skating and concerts, whose performers ranged from Dame Nellie Melba to John Philip Sousa. The north wing became a cinema and from 1935 was used as a repertory theatre until, in 1938, the Borough Council refused to renew the lease due to the rapidly deteriorating condition of the building. The outbreak of war precluded any plans for rebuilding and the Winter Garden was demolished in stages between 1940 and 1943.

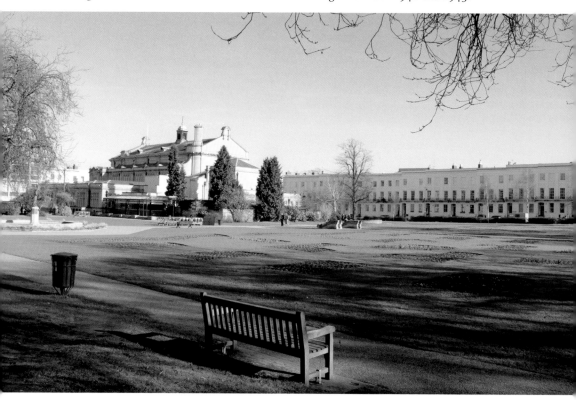

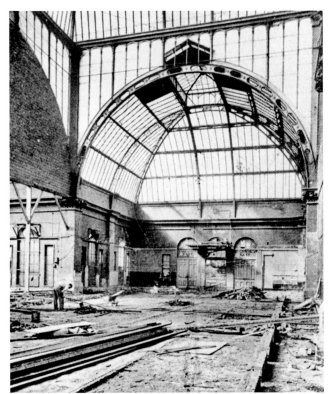

Winter Gardens
Here can be seen the *Daily Mirror* 'eight' gymnasts in August 1938, and the beginning of demolition in 1940. After the war the site, which had been requisitioned by the military, became the present Imperial Gardens. The bandstand, seen on the left of the 1938 photograph, was sold in 1948 to Bognor Regis, where it can still be seen.

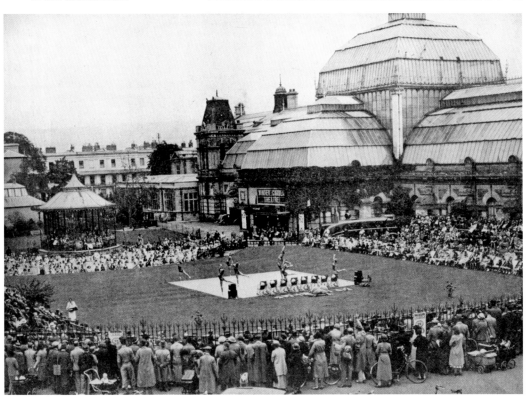

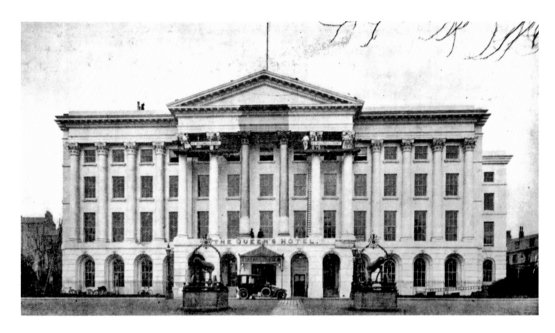

Queen's Hotel

Shown here in 1926, the Queen's Hotel has a commanding position at the head of the Promenade. When opened in July 1838, rooms were advertised at between 10p and 17½p, with servant's rooms available at 5p per night. Though its architecture is redolent of St Petersburg, it featured as the fictional Hotel der Konigin in the 1985 TV blockbuster, *Jenny's War*, set in 1941 Leipzig. Over the years, guests have included many of the musicians and actors who have appeared in the town, including Adelina Patti, Nellie Melba, Ignacy Paderewski and Sarah Bernhardt. The future King Edward VII lunched here as the Prince of Wales in May 1897 and, in March 1990, Britain's first female Prime Minister stayed here, together with five members of her Cabinet.

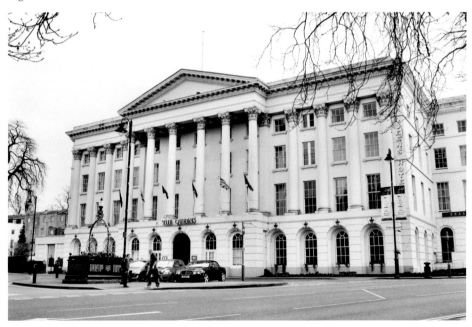

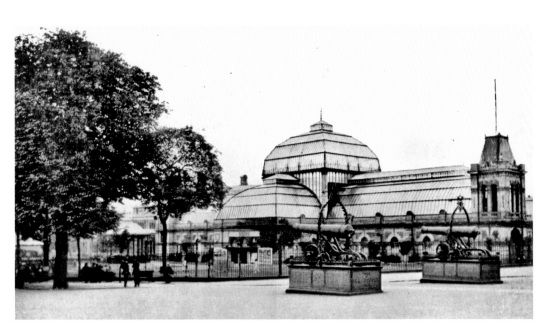

Queen's Hotel Cannons

Outside the hotel can be seen two cannons, captured at Sebastopol and placed here in 1858 on plinths commemorating those who died during the Crimean War. The cannons were removed for scrap in 1942 and today only one plinth remains. The iron canopy has also been removed from the entrance, but the Queen's retains its position as the town's leading hotel.

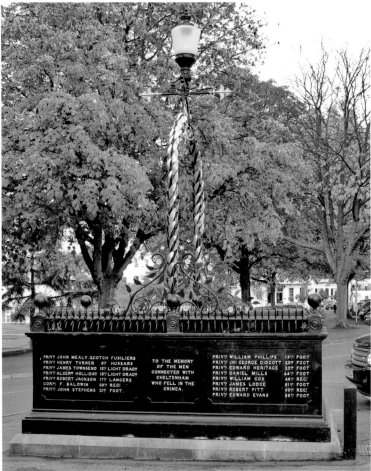

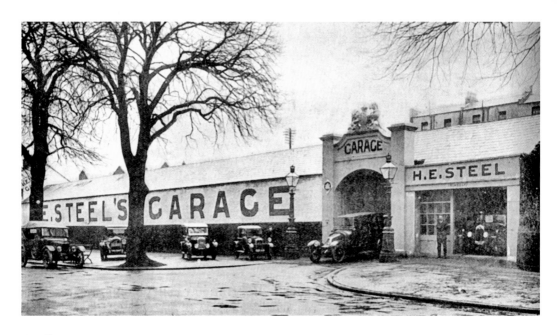

Steel's Garage

Shown in 1926, H. E. Steel's Garage displays the Royal Arms above the entrance to the former stables of the Queen's Hotel. Since 1996, the site has been occupied by the Broadwalk apartment block, echoing the architecture of the east side of Imperial Square. Two Victorian lamp stands, surmounted by crowns, still stand at the apartments rear entrance, while, closer to Vittoria Walk, can be seen the so-called Napoleon Fountain which once stood on the site of the hotel.

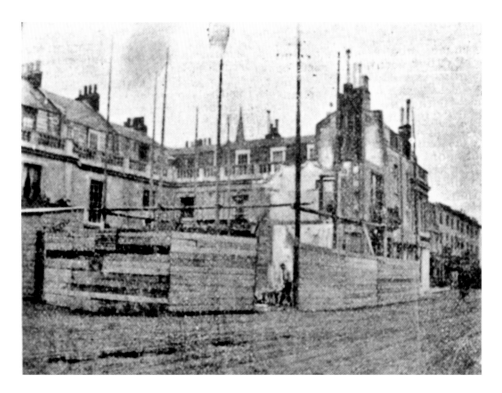

National Provincial Bank, Montpellier

Photographed in 1905, this shows the building of the National Provincial Bank on the site of the former coal exchange, adjoining Hanover House in Montpellier Walk. Originally developed in the 1840s, the walk is famous for its 'armless ladies' modelled on Greek Caryatids. Today the hushed tones of the bank have given way to the convivial atmosphere of an Italian restaurant.

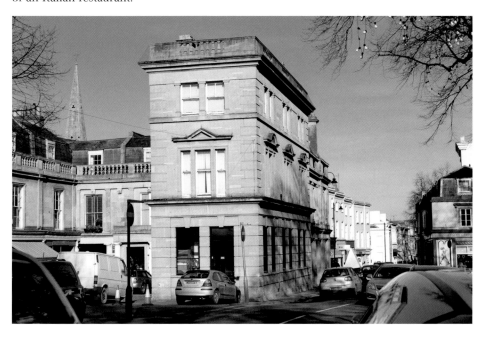

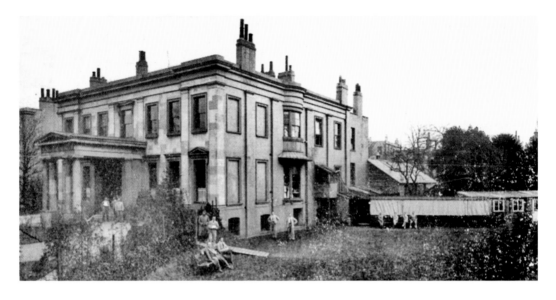

Suffolk Hall

The huge number of casualties generated by the Great War led the Red Cross to establish Voluntary Aid Detachment hospitals throughout the country. Several were opened locally including that at Suffolk Hall in Lypiatt Road. Described in 1889 as 'the finest old mansion of Cheltenham in [its] heyday ... as a Spa', it later became a boys' preparatory school.

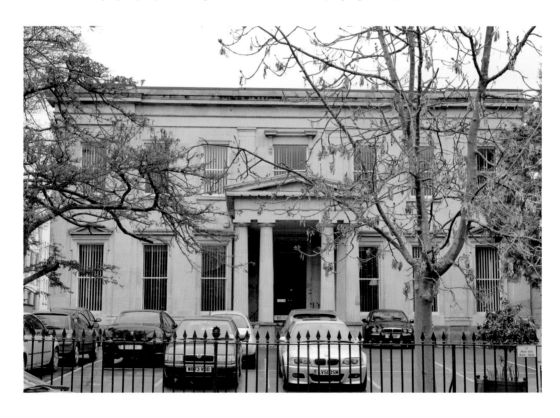

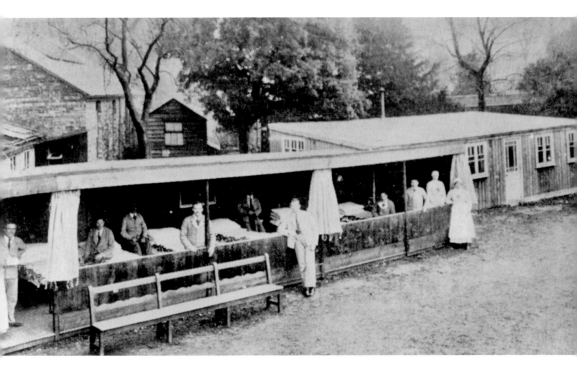

Suffolk Hall

Converted to a hospital in December 1914, the school's gymnasium and schoolroom became wards providing sixty-five beds with another eight beds in the open-air shelters, as shown in these two photographs. Before closing in March 1919, the hospital had treated 1,368 men. St Dunstan's, serving blind seamen and soldiers, took over the house in 1920. Renamed Southwood in 1923, it became a boarding house for Cheltenham College. Today, as Burlington House, it is home to the Victory Social Club.

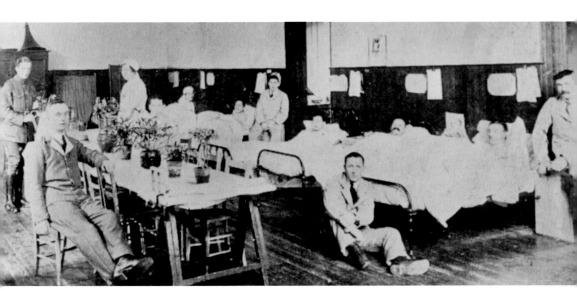

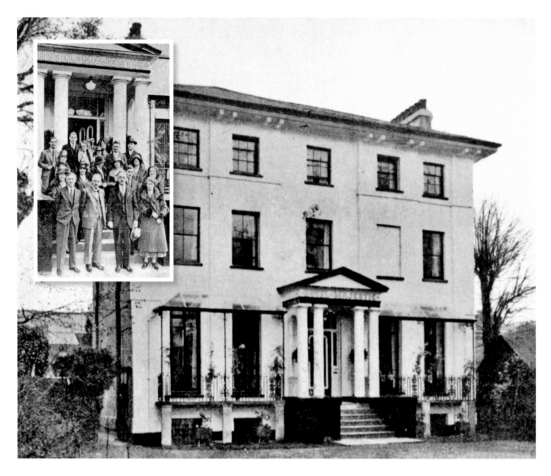

Hotel Majestic, Park Place

An enterprising local businesswoman, Emily Bayliss, opened the Hotel Majestic in Park Place in 1932. Converted from a private house named Nethermuir, the hotel flourished and within three years had expanded to take in the neighbouring house as well. These four photographs show the hotel as it was when it opened. Miss Bayliss became a town councillor, and a considerable benefactress to the town.

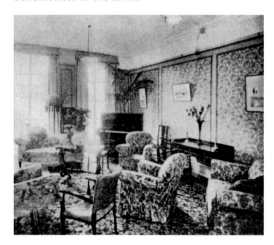

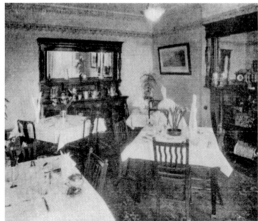

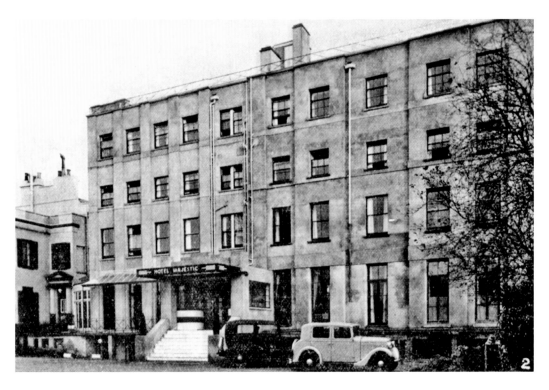

Hotel Majestic, Park Place
Many smaller hotels closed from the late 1960s onwards and in the 1980s the hotel was reduced to rubble and the present flats built on the site.

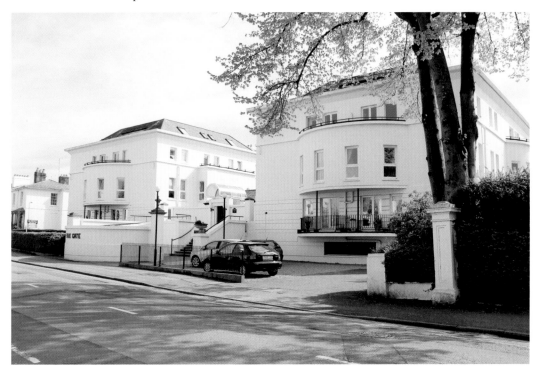

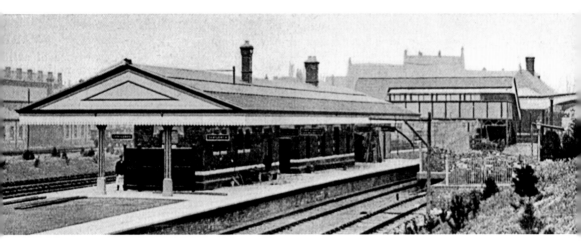

Malvern Road Station

Opened on 30 March 1908, Malvern Road Station was built on the Honeybourne line by the Great Western Railway. It removed the inconvenience of trains to Stratford having to enter and reverse out of St James's Station. Approached by a long drive off Malvern Road, the station had one island platform reached by a footbridge from the booking office. Along with St James', Malvern Road closed on 3 January 1966, leaving Lansdown as the town's sole station. The track is now used as a pedestrian and cycle way while a builder's yard occupies the former station site.

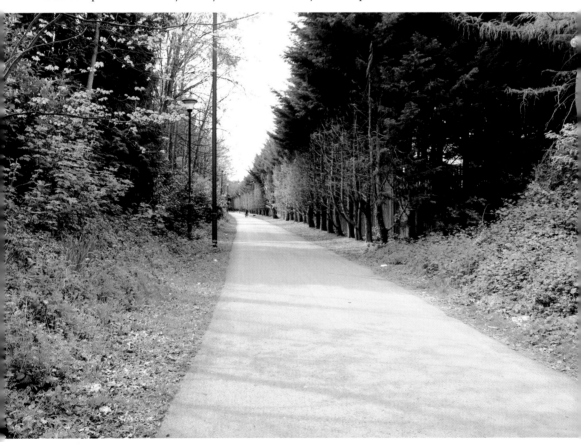

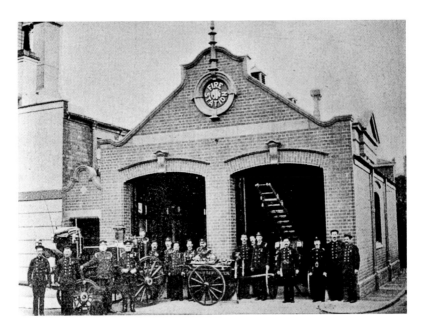

St James' Square, Fire Stations

A new fire station was opened in 1906 in St James' Square, adjoining the existing Engine House and situated immediately in front of the Synagogue. Twenty years after the outbreak of the Second World War, the fire service moved to their headquarters in Keynsham Road. Today both the old Engine House and station appear to be vacant.

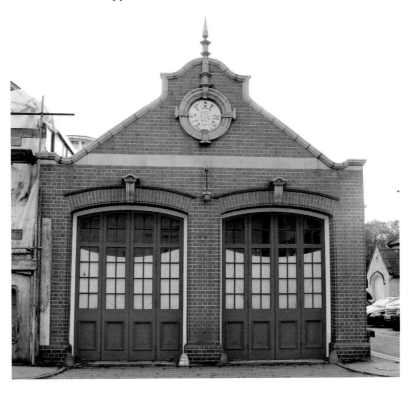

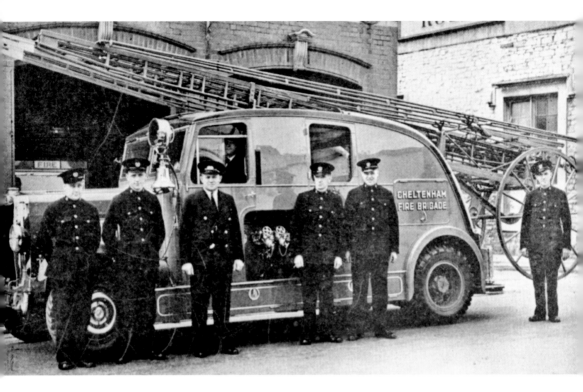

Keynsham Road, Fire Stations

This photograph, taken by fireman Andy Rood, is of the Keynsham Road depot shortly before demolition and redevelopment. Also shown is the fire engine acquired for £2,000 shortly before the outbreak of war in 1939.

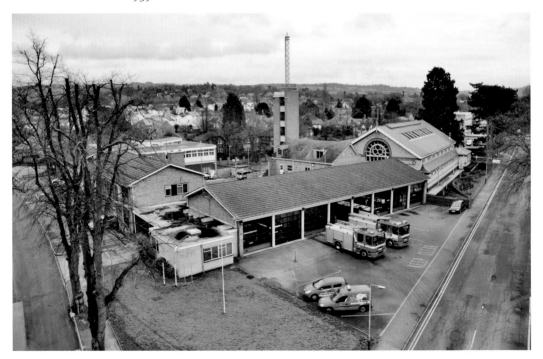

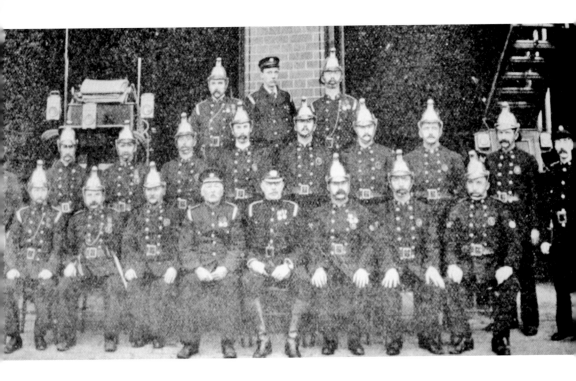

Some of the Crews, Fire Stations
The top photograph shows the crew of 1906 and the second photograph dates from 1885. The crew are named as: on ladder Captain A. Matthew, snr, and S. Broom; standing: Captain H. Pike, G. Errington, J. Such, S. Cowley jun., Joe Such, A. Mustoe, Supt. W. Baker, Captain C. Andrews, F. Carr, J. James, A. D. Middleton; kneeling: W. Edwards, C. Middleton, W. Andrews, A. Matthews jun., T. James.

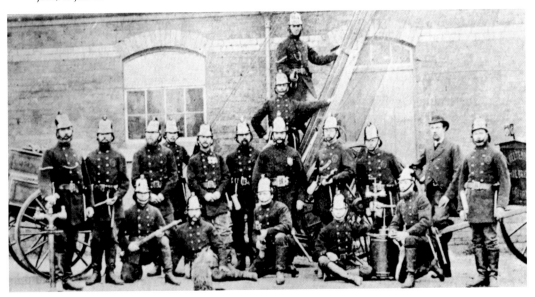

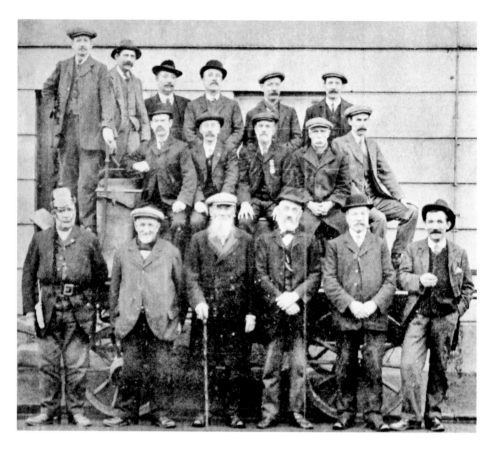

Some of the Crews, Fire Stations

The top photograph shows the retired crew. Top row: ex-firemen S. Cowley, E. Kent, C. Craddock, W. Cowley, E. Hall, E. Eager; second row: H. Fox, G. Sparrow, S. Broom, W. Edwards, F. James; third row: ex-Capt. H. Pike, ex-firemen J. Eager sen., G. Dale, M. N. Taylor, A. D. Middleton, J. Eager jun. The bottom photograph from 1913 shows the crew of that year outside the station with their 'Theobald' steam engine at the celebration of the centenary of their founding.

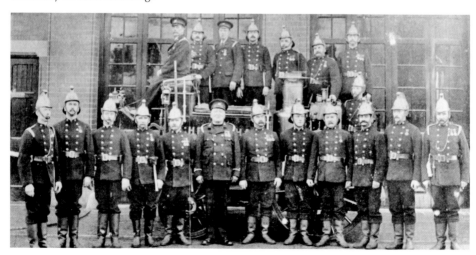

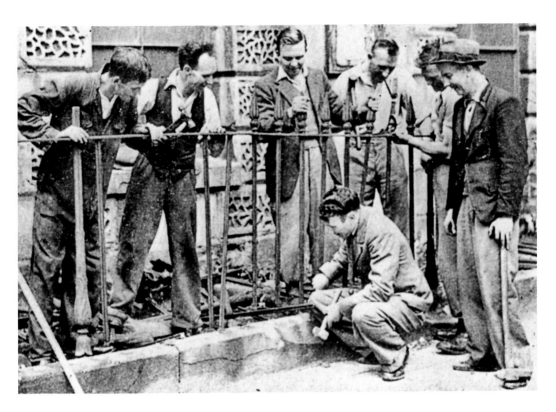

Railings, Royal Well

Many of the town's railings were removed in 1940 for recycling into armaments although, after the war, it was rumoured that they were never so used. Here are seen volunteers at work outside the Royal Well Chapel in St George's Road. The site of the Royal Well Chapel has long been a car park.

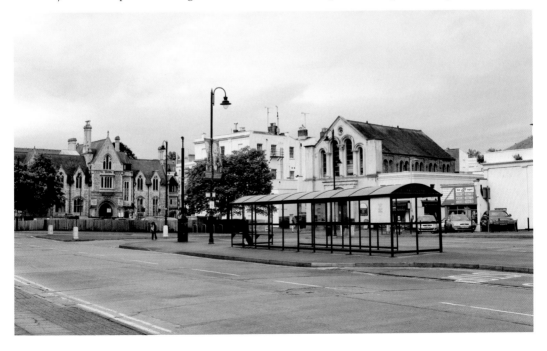

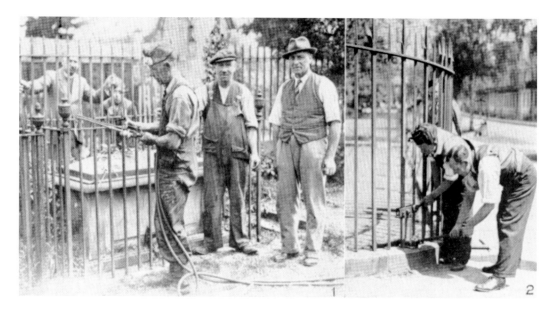

Railings

Top right shows the railings being removed from the Winter Garden and top left from St Mary's Churchyard, Charlton Kings. Below is the churchyard today.

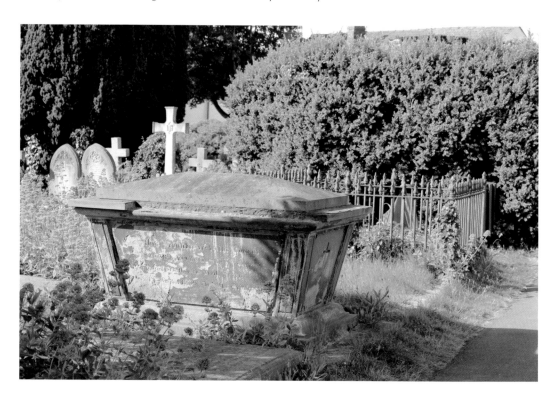

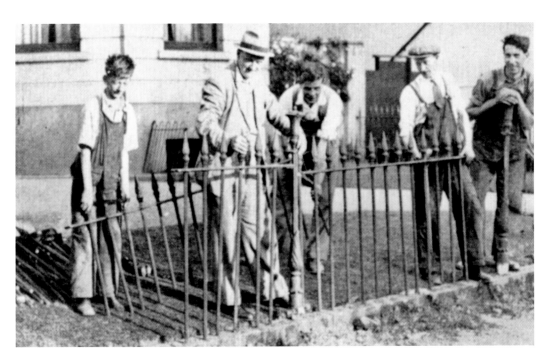

Railings, Pittville Lawn

Volunteers remove the railings in front of Roden House and Berkeley House in Pittville Lawn. Though in recent years much ironwork has been replaced, that outside Roden and Berkeley Houses is still missing, though the original railings survive on the Wellington Road side.

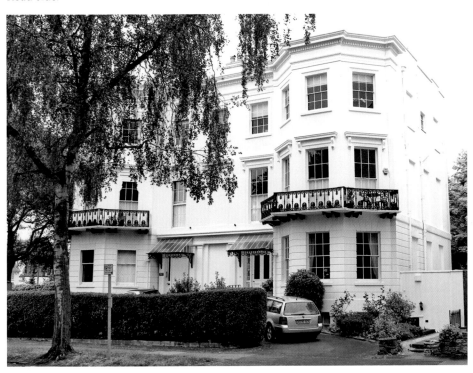

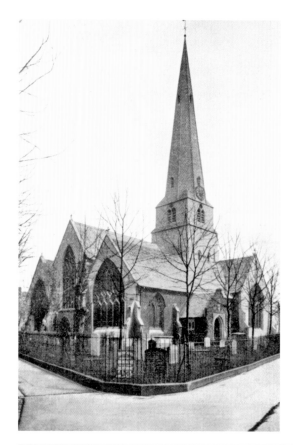

Railings, St Mary's Parish Church
The railings were also removed from St Mary's Parish Church in the town. Since then many of the gravestones have also been removed and the churchyard today is a haven of peace and quiet in the town centre.

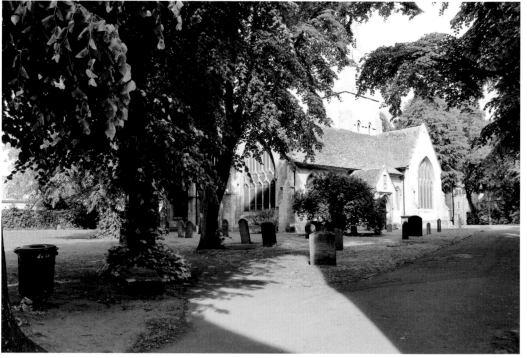

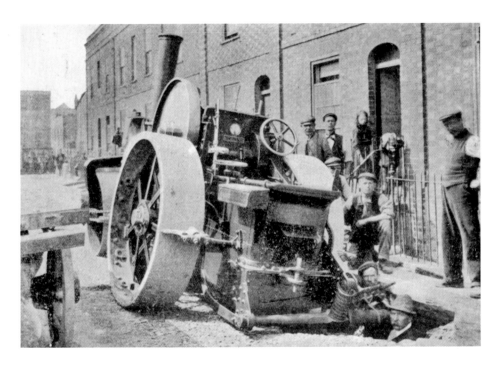

St Paul's Street South

Craters appearing in our roads are not just confined to the modern day. Here, back in 1907, a cellar has collapsed underneath the road causing the steam roller to fall into the hole! St Paul's Street South today looking towards St Gregory's church shows the present semi-detached houses, designed by Healing & Overbury, and date from the mid-1930s. Numbers 5 and 6 further up the street (not shown here) carry the symbol of Corpus Christi College, Oxford, that of a pelican plucking its breast to feed its young.

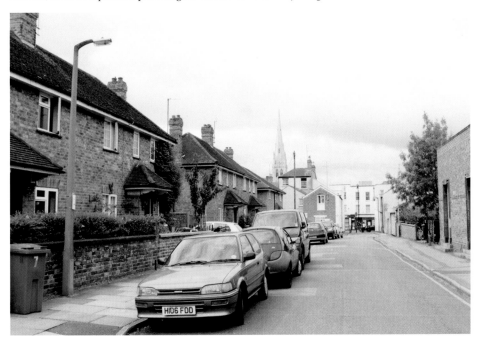

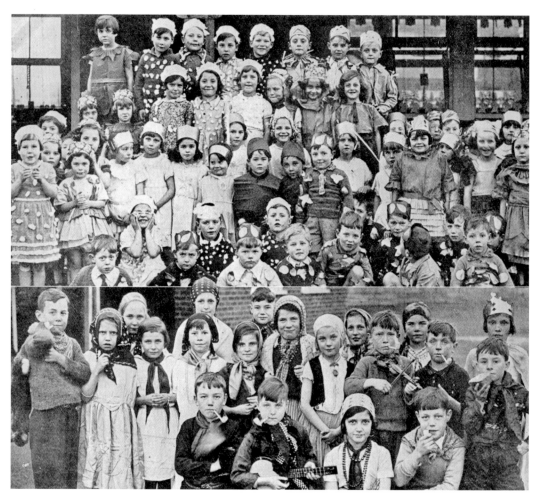

Whaddon Junior School
Whaddon Junior School children ready for their school play and Christmas party, 1938.

Acknowledgements

All old photographs are taken from the *Cheltenham Chronicle* and *Gloucestershire Graphic* apart from those on pages 5, 13, 19, 25, 52, 53, 62 (authors' own collections); 42, 64, 69, 73 (*Beautiful Britain* 1923); 44 (*Hadley's Guide to Cheltenham* 1856), 44, 67 (*Cheltenham Looker On*); 54 (*Rowe Cheltenham Guide* 1845). All new photographs are by Lynne Cleaver except for 39 (Alec Walters, Pates Grammar School), 88 (Andy Rood).

We acknowledge with thanks the help given by the staff of Cheltenham Family and Local History Library. Also thanks to our families and friends for their support and encouragement.